Crisis in Buenos Aires

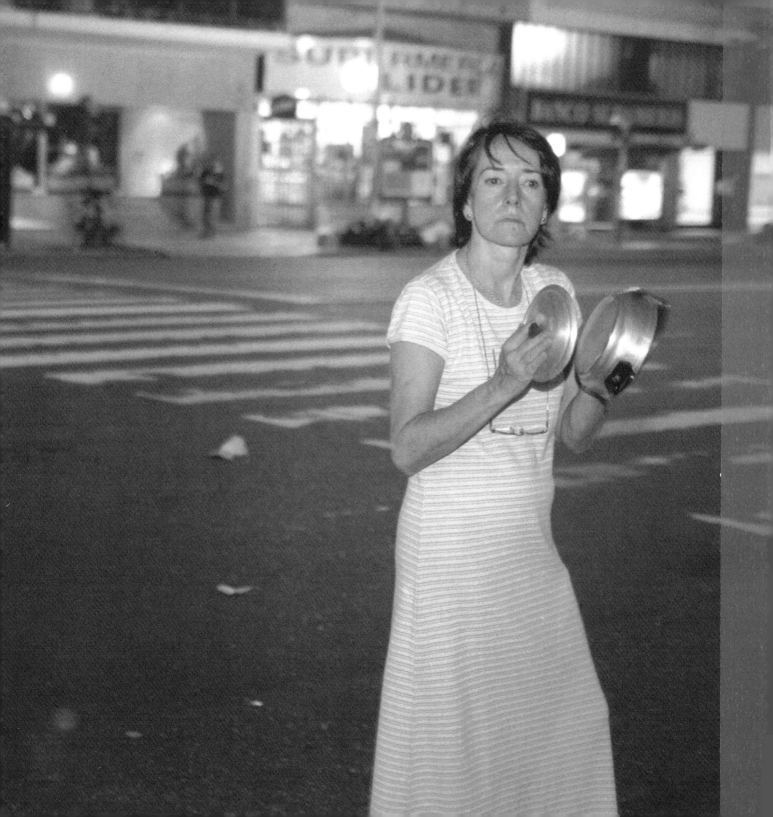

Crisis in Buenos Aires: Women Bearing Witness

Edited by
CYNTHIA SCHMIDT-CRUZ

Photography by
SILVINA FRYDLEWSKY

Photo preparation by
PRISCILLA SMITH

Juan de la Cuesta
NEWARK · DELAWARE

Juan de la Cuesta—Hispanic Monographs
An imprint of LinguaText, Ltd.
270 Indian Road
Newark, Delaware 19711-5204 USA
(302) 453-8695
Fx (302) 453-8601

www.JuandelaCuesta.com

MANUFACTURED IN THE UNITED STATES OF AMERICA

ISBN: 978-1-58871-124-3
FIRST EDITION

Contents

Photographs by Silvina Frydlewsky

1. "Cacerolazo de clase media" / "Middle Class *Cacerolazo.*" Neighborhood of Belgrano.
2. "Cacerolazo en Plaza de Mayo" / "*Cacerolazo* at the Plaza de Mayo."
3. "Banderazo y cacerolazo" / "*Banderazo* and *Cacerolazo.*" Neighborhood of Belgrano.
4. "Tolerancia cero" / "Zero Tolerance." The Federal Police taking away a detained demonstrator from the Plaza de Mayo, the night of the *cacerolazo* in December, 2001.
5. "Café Tortoni, tarde de domingo" / "Café Tortoni, Sunday Afternoon." Avenida de Mayo.
6. "Café Tortoni, tarde de nostalgia" / "Café Tortoni, Nostalgic Afternoon." Avenida de Mayo.
7. "Cacerolazo popular" / "Popular *Cacerolazo.*" Avenida de Cabildo, Neighborhood of Belgrano.
8. "Indignación, impotencia…" / "Indignation, Impotence… ." Avenida de Cabildo, Neighborhood of Belgrano.
9. "Ciudad imponente e impotente" / "Imposing, Impotent City." Avenida 9 de Julio and Avenida Corrientes.
10. "Desolación" / "Desolation." Avenida de Cabildo, Neighborhood of Belgrano.
11. "Solo una ayuda me salvará" / "Only a Little Help Will Save Me." Right in the middle of Avenida Corrientes.
12. "Contrastes en el Teatro Colón" / "Contrasts at the Teatro Colón."
13. "Mi casa" / "My House." Plaza San Martín.
14. "Contrastes" / "Contrasts." View of the Villa de Emergencia de Retiro from the 25 de Mayo Expressway.
15. "Madre del dolor" / "Mother of Sorrow." Beatriz Orresta with her son Santiago, who died of malnutrition several months after the photo was taken. Tucumán Province.
16. "La desnutrición: la madre de la desesperanza" / "Malnutrition: The Mother of Despair." Tucumán Province.
17. "El oro de los pobres" / "Poor-Person's Gold." An indigent woman looks for food right in the middle of Avenida Santa Fé, a well-known residential area of the Buenos Aires middle class.
18. "El oro de los pobres II" / "Poor-Person's Gold II." A group of men look for food in the neighborhood of Recoleta, a residential and main strolling area of the Buenos Aires middle and upper classes.
19. "Teatro Colón" / "Teatro Colón."
20. "Galerías Pacífico" / "Galerías Pacífico."
21. "Recorriendo la 9 de Julio" / "Wandering about the Avenida 9 de Julio."
22. "En familia" / "With the Family." Wandering about the streets of the upper class neighborhood of Recoleta.
23. "En familia II" / "With the Family II." Wandering about the streets of the upper class neighborhood of Recoleta.
24. "Tangomanía" / "Tangomania."
25. "Las Madres de la Plaza" / "The Mothers of the Plaza." Plaza de Mayo.
26. "Profesión: cartoneros" / "Profession: Cardboard Gatherers." Neighborhood of Recoleta.
27. "Profesión: cartoneros II" / "Profession: Cardboard Gatherers II." Neighborhood of Recoleta.
28. "Profesión: cartoneros III" / "Profession: Cardboard Gatherers III." Neighborhood of Palermo, intersection of Calles Salguero and Juncal.
29. "Los hombres del mañana" / "Tomorrow's Men." Calle Florida.
30. "Pan" / "Bread." A malnourished child in the province of Tucumán, in 2002.

Preface

DECEMBER 2001 WITNESSED TUMULTUOUS events in Argentina, precipitated by the news that Argentina would default payment on its international debt. Bank accounts were frozen, people lost their life savings, and street protests turned to violence. A crisis in leadership led to five presidents in less than two weeks. Many middle class Argentines slipped into poverty, and thousands were reduced to scavenging in the trash in order to survive.

My colleague Gladys Ilarregui, moved by what her fellow Argentines were experiencing, came upon the idea of collecting poetry that expressed the new reality in Argentina. She invited me to collaborate, and we decided to create an exhibition of poems and photos describing the crisis. Gladys put out a call for Argentine women poets to submit their creative work, circulating the request in academic and non-academic poetic networks both in and outside of Argentina.

We found the photographer whose work we would display when Gladys showed me a clipping from the *Washington Post* about the crisis. It was the article by Santiago O'Donnell, reprinted in this collection, and was illustrated with the powerful image of a woman bent over the trash (photo 17 in this book). With an expression of rapt concentration (almost tenderness), she carefully (almost lovingly) grasps a small white bag retrieved from within a larger black bag; another pink bag is nestled between her feet. Beside her, partially concealed by her generous body, is a shopping cart to transport her findings. In the background are brightly lighted business establishments and well-dressed pedestrians who ignore her presence. We contacted the photographer, Silvina Frydlewsky, who had a full portfolio of stunning photos of the crisis and was delighted to participate in the project.

The Latin American Studies Program at the University of Delaware, of which I served as director from 2003-2006, became the natural sponsor for the program, with collaboration from the Department of Art for the visual component. Thanks to the enthusiastic support from the department's acting chair, Suzanne

Austin, we enlisted Priscilla Smith as exhibition coordinator and photography curator, Raymond Nichols for the graphic design and printing of the poetry, and Jon Cox for the printing of the photos.

As plans kept rolling, "Buenos Aires: A Tale of Two Cities. Mapping the New Reality through Poetry and Photography" grew to become a traveling exhibition of poetry and photography, complemented by a speakers' forum about crisis and change in Latin America. Thirty-four of Silvina's photos were chosen for the exhibition; they were grouped into clusters of "dark" and "light" images: the former capturing the devastating power of economic collapse as well as the resilience of the people of Buenos Aires, and the latter showing the beauty of this grand city, once known as the Paris of South America. The eighteen poems selected for the exhibit explored the new vocabulary and new reality of Argentina as residents struggled to come to grips with the crisis. First displayed at the University of Delaware in October 2003, the exhibit moved to Delaware Technical and Community College in Georgetown, Delaware, the following month, and was displayed at the Wilmington Latin American Community Center in March 2004.

The UD venue saw a constellation of events related to the exhibit. The Latin American Studies Program hosted three visiting Argentine scholars who participated in the project: Silvina Frydlewsky, the featured photojournalist; Delfina Muschietti, Argentine poet, translator, and professor at the University of Buenos Aires; and journalist Santiago O'Donnell, whose poignant essay led us to Silvina. A lecture series delivered by specialists in Latin America helped viewers understand the visual exhibit by offering perspectives on Argentine reality and the current crisis. The opening session featured talks by O'Donnell and Peter Hakim, president of the Inter-American Dialogue, and was moderated by Ralph Begleiter, UD Rosenberg Professor of Communication and Distinguished Journalist. Marcelo Cima, cultural attaché of the Embassy of Argentina in Washington, D.C., welcomed the audience and expressed his appreciation of UD's project about Argentina. A panel discussion focusing on contemporary Argentine culture and politics comprised the closing event. The speakers were Reinaldo Laddaga, professor of Romance Languages at the University of Pennsylvania; Enrique Peruzzotti, professor of political science and government at Torcuato Di Tella University, Argentina, and fellow at the Woodrow Wilson International Center for Scholars; and John Deiner, UD political science professor; and the moderator was Julio Carrión, also a UD political science professor.

Two poetic events rounded out the offerings: Delfina Muschietti presented a bilingual poetry translation workshop, and Gladys Ilarregui organized a poetry reading delivered by her students. In addition, Silvina Frydlewsky offered a photojournalism workshop organized by Priscilla Smith. Many UD Spanish classes visited the exhibition, and instructors incorporated it into their curriculum. Spanish instructor Stacey Hendrix designed a creative lesson plan to enable Spanish students to analyze and reflect on the exhibit. Several high school groups toured the exhibit, and a teaching workshop based on the project for area teachers provided additional outreach to high schools.

The exhibitions in Georgetown and Wilmington were also accompanied by presentations and discussions, as well as receptions with music.

Many people lent their time and talents to help make this interdisciplinary project a resounding success. UD administrators were enthusiastic about the plan from its inception, and we are grateful to Provost Dan Rich; Mark Huddleston, Raymond Callahan, and Gretchen Bauer, former dean and associate deans of the College of Arts & Sciences; and Richard Zipser, Chair of the Department of Foreign Languages and Literatures, for believing in the value of this endeavor and lending their support in myriad ways. Members of the organizing committee included Julio Carrión, Suzanne Austin, and Julie Demgen, with Ralph Begleiter serving in an advisory capacity. The late Mary Hempel masterminded the publicity and Barbara Stein designed a beautiful brochure and poster. Persephone Braham served as Webmaster for the project, Suzanne Cherrin coordinated the exhibit monitors, the late Judy McInnis helped with translation and transportation, and Marta Cabrera-Serrano along with students Sally Goodfellow and Kathleen Payne assisted with publicity, outreach to high schools, and Spanish-English interpretation. Priscilla Smith and her exhibition team—composed of art students Andrew Bale, Rebecca Dietz, Ashley Mask-Harris, and Sherry Wiernik—provided expert installation and deinstallation of the exhibit at each venue. Our point person for the exhibit at the Delaware Technical and Community College in Georgetown was John Deiner. At the Latin American Community Center in Wilmington, Executive Director Maria Matos gave the exhibition her seal of approval and Riccardo Stoeckicht, assistant executive director, provided enthusiastic support and tireless help with logistics.

All of this would have been impossible without substantial funding, and we were fortunate to have the backing of the University of Delaware as well as several outside sponsors. Generous support from the College of Arts & Sciences and the Center for International Studies gave us firm financial footing, and many other University departments and units also contributed, including the Faculty Senate Committee on Cultural Activities and Public Events, the Visiting Scholars Program, Student Centers and HOLA (Latino Campus Organization), the Office of Multicultural Programs and the Center for Black Culture, the Honors and Women's Studies Programs, and the Departments of Foreign Languages and Literatures, Art, Political Science and International Relations, Geography, Anthropology, Sociology, English, and History. Outside funding was secured from the National Endowment for the Arts, the Delaware Division of the Arts, the Delaware Humanities Forum, the International Council of Delaware, and the Office of Education and Science of the Embassy of Spain.

By all measures, "Buenos Aires: A Tale of Two Cities. Mapping the New Reality through Poetry and Photography" exceeded expectations. It was very well received by the public: over 1,100 people toured the exhibit at UD alone, and all the events were well attended. The Latin American Community Center was so pleased to have the exhibit that they asked if we could extend the loan period, and it continues on display there.

The idea of turning the project into a book evolved as we realized that this superb poetry and

photography that put a human face on the crisis needed to reach a larger public. For the book, we made a new selection from Silvina's ample portfolio, choosing the photographs that best communicated the sentiment of each poem; this resulted in fewer "light" images and a greater concentration of those that showed the reality of the crisis.

Santiago O'Donnell gave us rights to reprint the article he wrote for the *Washington Post*, Delfina and Gladys prepared essays, and Stacey adapted and expanded her original lesson plan. Diana Bellessi, whose gripping poem "Muerte por hambre" is included in the collection, felt so strongly about the value of publishing the poetry alongside Silvina's powerful images that she contributed a piece of her prose-poetry. We thank Adriana Hidalgo editora and Lom Editorial for granting us permission to reprint Diana's texts. We were fortunate to bring in two new collaborators, both highly respected experts in their fields: Anthony Faiola and David William Foster.

Each essayist reflects on the crisis from a different angle. Anthony Faiola, who was *Washington Post* bureau chief in Buenos Aires from 1996 to 2002, witnessed the events first hand and accompanied Silvina on many of her photo shoots. His introductory essay provides poignant stories that illustrate the crushing effects of the crisis on the lives of ordinary Argentines, along with a background and explanation. Santiago O'Donnell's remarkable essay delivers a penetrating account of how the crisis has altered the city and its people, coupled with his own story of how his abiding love for his country motivated him to leave behind a comfortable life in the U.S. and return to Argentina, despite its problems.

David William Foster's interpretative essay draws on his broad and deep expertise in Argentine culture, urban photography, and gender studies to reveal how the photographs and poetry in this volume reflect a "heightened moment of sociopolitical consciousness in contemporary Argentina." His overview of the work of various post-1983 Argentine photographers situates Frydlewsky's photographs within the wider context of a new interpretative gaze of Buenos Aires, and explains how photographs create visual meanings as they provide a critical interpretation of national life. His in-depth commentary on the cover photograph, the photos of *cartoneros*, and the poems that accompany them, sheds light on women's role in a historically masculinist society and explains the phenomenon of the trashpickers as a result of the trash produced by neoliberalism and prosperity.

Gladys Ilarregui begins her essay by examining how the very origins of Buenos Aires were built on contradictions—the intersection of foreign and autochthonous elements, the European and indigenous populations. This phenomenon culminated in Carlos Menem's (Argentina's president from 1989-1999) courting of First World economy, a factor that helped build to the crisis. Events surrounding the crisis— political, economic, and civil instability that were part and parcel of it—provoked the women poets to write. Gladys discusses how each poem reflects the poet's experience of the crisis, transmitting a new

vision of Buenos Aires—of hunger, chaos, and the culture of cast-offs—and using a new vocabulary of failure and betrayal, undoing clichés of glory and heroism. Gladys expresses the hope that in this art others can see the reflection of "our splendor and our misery."

Delfina Muschietti provides a moving personal account of her experience of the crisis and the process of writing the poems that are included in this volume. In the first part of her essay she discusses how experience, sensation, and memory become transposed into the poetic word. "Thieving the theft of oblivion," the process of poetic creation pursues the language of the dream in a vain attempt to recover an underground memory that has been stolen from our waking memory. The second part of her essay describes the genesis of her poems and addresses the difficulties in translating the poetry from Spanish to English, insofar as language is inextricably tied to a specific cultural memory.

Diana Bellessi offers a meditation on the voice of poetry, the role of poetry, and the poet in the market economy. In a society that sees everything that is outside the market economy—a category that includes poetry—as trash, poets learn from the *piqueteros* and *cartoneros* the dignity of resistance, the insistence to claim that "I am still a human being."

The lesson plans by Stacey Hendrix, with a host of creative ideas for classroom use, offer practical applications of this book for instructors. While her experience with the material was in the Spanish language class, her appendix includes a wide variety of exercises that can be used in diverse disciplines such as literature, Latin American Studies, and Women's Studies.

What all contributors to the book have in common is their desire to put a human face on the crisis and to express their hope that Argentina will continue to progress beyond those turbulent days of December 2001. By using art forms to communicate and disseminate socio-economic reality, this book aims to recover and pay tribute to the creative resistance of the people of Argentina.

I would like to acknowledge those who helped with the production of this book. First of all, Gladys Ilarregui has helped in ways too numerous to list. She has offered support and guidance for every aspect of the process, and her encouragement and conviction in the value of this project have carried me through. Priscilla Smith graciously offered to reformat the digital images. Laura Salsini and Meghan McInnis-Domínguez edited and corrected the articles, and Julie Demgen, Stacey Hendrix, and Emily Helmeid served as proof-readers. Thanks to Michael Bolan of Juan de la Cuesta—Hispanic Monographs for doing a superb job designing and formatting this book. Finally, I would like to thank Tom Lathrop and Juan de la Cuesta—Hispanic Monographs for believing in this project and agreeing to take it on.

Cynthia Schmidt-Cruz
Editor

I. Essays

Introduction: The Crisis, Illustrated

Anthony Faiola

THE TRAGEDY OF A NATION was reflected in little Santiago Orresta's eyes.

I first glimpsed them during the summer of 2002, a time when the full weight of Argentina's economic collapse was crushing its citizenry. Photographer Silvina Frydlewsky and I set out to put a face on the crisis during a trip into the heart of one of the nation's poorest provinces, Tucumán. I had been based in Buenos Aires as *The Washington Post's* South America Bureau Chief since 1997, covering a host of often tragic news stories from Tierra del Fuego to the Amazon jungle. But no single event left more of an imprint on my mind than that day we stumbled upon Santiago, then seven months old and lying listlessly in the arms of his distraught mother (see photo 15 "Madre del dolor.")

On an arid strip of land off a worn highway, Beatriz Orresta, then twenty years old, cradled him in front of a small wooden shack, watching helplessly as her infant son withered from starvation. Hit hard by the economic collapse, she and her husband, a 21-year-old day laborer, could no longer afford enough milk to feed Santiago or his two older siblings, both of whom were also ill from lack of food. Suffering from malnutrition herself, Beatriz had stopped lactating. Santiago, his eyes sunken and vacant after weeks of surviving on boiled *mate*–a South American herb tea said to ease hunger pains—would pay the highest price. A few months after our trip to the northern highlands to document the crisis, he would die from complications related to malnutrition. Santiago would become one of the smallest of many victims during those devastating days.

For me, the plight of the Orrestas would encapsulate the horror of Argentina's financial collapse. Perhaps the single most destructive economic crisis the world has seen since the Great Depression, the turmoil experienced in Argentina during the early 2000s illustrated in painful relief the power of economics to lay waste a nation. Traditionally proud, the Argentines fell into a tailspin of despair as their nation diminished in ways not previously imaginable.

In the following pages, the reader will find images of those times–reflections both in photography and poetry that powerfully convey a sense of what was lost. In many ways, this is a tribute to the resilience of the Argentine people, a tumultuous, passionate, and creative lot who have seen more than their fair share of bad times. These would be their worst. Look closely, if you will, at photo 24, "Tangomanía," where you'll see a band of young musicians finding solace in the melancholic tango, a sound born in restless

nineteenth-century Buenos Aires. As a new generation of Argentines rediscovered the tango, its sorrow and longing would prove a disturbingly apt soundtrack for the crisis years. Yet in those tunes was also a suggestion of the indomitable Argentine spirit, one that in the past few years has already begun to gather itself from the ashes. Let this book be an expression of hope that it may one day soar again.

A Roller Coaster of History

Since its declaration of independence from Spain in 1816, Argentina had always been a nation apart in Latin America. Populated largely by immigration from Italy, France, Great Britain, and Germany, it has long stood out as a country more akin socially and ethnically to Europe than to its more diverse neighbors in the New World. The cosmopolitan capital Buenos Aires became renown worldwide as the Paris of Latin America; the standard of living there more on par with Naples or Prague than Lima or Mexico City.

Enjoying a title as the world's bread basket during the turn of the last century, the Argentina of the 1920s was a high-flying country, richer than France and with more cars than Japan. Then came a long period of slow but steady decline as Argentina weathered a legacy of chaos and division during the mid to late twentieth century. In search of their "workers' paradise," Juan and Eva Peron declared war on the rich during the 1940s, a battle that would only generate a new cycle of corruption and failed military rule. During the "Dirty War" of the 1970s, military rulers arrested tens of thousands of people, 15,000 of whom would never resurface, forever remaining "desaparecidos"–or disappeared persons.

The restoration of democracy in Argentina would bring a new series of plagues. To be sure, when former President Carlos Menem touted his "New Capitalism" in the 1990s–selling off virtually every state owned enterprise from the subway system to local water works–the rich got richer, many illegally, while the poor sunk deeper and deeper into poverty. One now famous photograph underscored the unabashed decadence of that era. It captured María Julia Alsogaray, Argentina's former environmental minister, clad only in a luxurious fur. Appearing on the cover of a popular magazine, that photo would shockingly underscore the contempt she held for her position as well as the arrogance of an official reveling in privilege even as her nation slipped into crisis. Alsogaray would later wear the same fur to an international environmental conference in Europe, sparking a loud round of jeers from peers stunned at her gumption in wearing such a coat to a forum to protect wildlife. She–along with many former officials of the Menem era—would later be prosecuted for bilking millions of dollars worth of state funds.

Yet until the full force of the crisis struck, some things about Argentina never really changed. Through it all, it had somehow managed to remain the richest, best-educated, and most cultured nation in Latin America. Luciano Pavarotti still performed at the Teatro Colón, Buenos Aires's celebrated opera house modeled after La Scala in Milan. The city's legendary café society thrived, with intellectuals debating passages from Jorge Luis Borges over croissants and thick espresso.

But all of that would change during the crisis years. Inside the smoky dens of the literati such as the

centenarian Café Tortoni, Silvina and I once tried to find some semblance of those heady days. Instead, we found the embarrassed looks of regulars nursing one cup of coffee for hours because they could no longer afford to order more. It would stand out as one example of how virtually all aspects of daily life in Argentina would no longer be the same.

In the years since, economists and politicians have debated what ultimately provoked the financial collapse. Perhaps we will never see full agreement on the single biggest factor that pushed Argentina over the edge. But it will not be for lack of theories. Some of the world's leading economists have blamed over-eager globalization policies mixed with the harsh austerity programs imposed on Buenos Aires by the International Monetary Fund. But just as many have blamed the Argentine government itself for its runaway spending, systematic corruption, and a woeful inability to lead.

The facts, however, are not in dispute. It was a multifaceted and complex collapse—a train wreck that some saw coming since Argentina first fell into recession in 1999. In January 2002, its coffers emptied, and unable to impose more austerity on its suffering people, Argentina would stage the largest debt default in history—ceasing payment on some $136 billion worth of foreign bonds and loans. It happened as the peso, which had been pegged to the U.S. dollar at a one to one rate for most of the 1990s, entered into a devastating devaluation that saw its value plummet as low as 25 cents on the greenback.

At the same time, food manufacturers and grocery stores raised prices even as individual earning power took a historic tumble. Some products went up for obvious reasons—because they were imported goods denominated in dollars and now commanded higher prices in a nation where the peso was no longer equal to the U.S. currency. But as the nation disintegrated into an "every man for himself" attitude, domestic price gouging took a massive toll on the populace. Take, for example, the price of flour and canned tomatoes—which jumped 166 percent and 118 percent respectively—even though both were locally made goods that experienced little increase in real production costs.

The impact was monstrous. Before 1999, when the country of 36 million inhabitants first slipped into recession, Argentina's per capita income was $8,909—double Mexico's and three times that of Poland. But by 2002, per capita income had sunk to $2,500, roughly on a par with Jamaica and Belarus. The economy shrunk by 17 percent in 2002 alone, putting the total decline near 25 percent since 1999. By comparison, during the Great Depression years of 1930-33, the Argentine economy shrunk by only 14 percent.

After the January 2002 default and devaluation, what had been a snowball of poverty and unemployment suddenly turned into an avalanche. A record number of Argentines, more than half, fell below the official poverty line. By August 2002, more than one in five no longer had jobs.

Argentines watched, horrified, as the meltdown dissolved more than their pocketbooks. Every Argentine, no matter their social class, had a crisis story. Amalia Lacroze de Fortabat, one of the country's richest women, was forced to offer up paintings by Gauguin, Degas, Miró, and Matisse at a Sotheby's auction to cover her losses. For many of Argentina's well-to-do, the sale was the ultimate humbler, a symbol

of decline in international stature of the local jet set.

The people would soon lash out at their political class, who along with foreign investors became the biggest marks of blame. In Buenos Aires, a teaming capital of 12 million, people took to the streets in *cacerolazos*—a traditional form of protest in Latin America in which furious residents demonstrate their rage by banging pots and pans from every corner of their neighborhoods. I can still recall the tinny sound of Argentine anger ringing out from even the most fashionable neighborhood of Buenos Aires—Barrio Norte, home of genteel European buildings with French moldings and parks filled with Romanesque statuary. By 2002, however, the elegance of Barrio Norte would become a stage for almost nightly performances of cat calls and ringing cookery.

The fury of the people would not be contained by the banging of kitchenware alone. Impoverished and furious, Argentines blamed their leaders for their woes, sparking a wave of attacks against elected and appointed political figures and igniting calls for an overhaul of the two-decade-old democratic system that citizens called bloated, corrupt, and unresponsive. Ultimately, Argentina's political instability at the end of 2001 would lead to four different presidents within two weeks. At the same time, it became open season on politicians of every stripe.

I vividly remember the jarred face of Franco Caviglia, a tall, dashing congressman, who had been enjoying an espresso at the Casablanca café near Argentina's neoclassical Congress building when a group of people advanced on his table. They berated him with insults and shoves, leading Caviglia to attempt a fast exit. But the mob of normally level-headed diners barred the door, holding him captive for a half hour before he was rescued by police. His crime was being a politician in Argentina.

"I understand their rage," Caviglia, a congressman, would later tell me. "The people feel as if we have failed them, and maybe they are right. But if we're going to get out of this crisis, we need to restore faith in our institutions, not tear them down."

But by then, Argentina as we knew it was disintegrating. In July 2002, the eve of the 50th anniversary of the death of the once beloved Eva Peron, thieves swiped the head of a new statue of her. Nothing, really, was sacred anymore. Ads by concerned citizens appeared on television, asking Argentines to look inward at a culture of tax evasion, incivility, and corruption. But nobody seemed to be listening. As desperation grew, people found themselves capable of acts they once thought unimaginable. One of the most shocking examples of the nation's altered status took place in the vast urban slums ringing Rosario, Argentina's second largest city. A cattle truck had overturned in March 2002, spilling twenty-two head of prime Angus beef across a wind-swept highway. Some were dead. Most were injured. A few were fine.

A mob moved out from Las Flores, a shantytown of trash heaps and metal shacks boiling over with refugees from the economic collapse. Within minutes, 600 hungry residents had arrived on the scene, wielding machetes and carving knives. Suddenly, according to the accounts of those I interviewed who were present on that day, a cry went up.

"Kill the cows!" someone yelled. "Take what you can!"

Cattle company workers attempting a salvage operation backed off. And a slaughter began. The scent of blood, death, and fresh meat filled the highway. Cows bellowed as they were sloppily diced by groups of men, women, and children. Fights broke out for pieces of flesh in bloody tugs of wars.

"I looked around at people dragging off cow legs, heads, and organs, and I couldn't believe my eyes," said Alberto Banrel, 43, who had worked a construction job until January 2002 –a month that was to be considered among the worse of the crisis. "And yet there I was, with my own bloody knife and piece of meat. I felt like we had become a pack of wild animals . . . like piranhas on the Discovery Channel. Our situation has turned us into this."

The Victims

The tragedy struck hardest, however, at the middle class, the urban poor and the rural farmers. Their parts of a once-confident society appeared to have collapsed—a cave-in so complete as to leave Argentines inhabiting a barely recognizable landscape.

With government statistics showing 11,200 people a day were falling into poverty—earning less than $3 a day—Buenos Aires, a city once compared to Paris, became the dominion of scavengers and thieves at night. Newly impoverished homeless people emerged from abandoned buildings and rail cars, rummaging through trash in declining middle- and upper-class neighborhoods. People from the disappearing middle class turned to pawn shops to sell anything of value to put food on the table. I was particularly touched by the story of Vicente Pitasi, then 60 and jobless, whom I interviewed one day in the center of Buenos Aires after he had just sold his wedding ring for a few pesos. "I have seen a lot happen in Argentina in my day, but I never lost hope until now," Pitasi told me. "There is nothing left here, not even our pride."

In the worst period of the crisis—early to mid 2002—there was nowhere you could turn without literally coming face to face with the tableaux of suffering it had sowed. After leaving a steak house with a group of friends one evening in July 2002, we came across a well-dressed elderly woman begging for funds to pay for her brother's heart medication. We gave the woman a fist full of pesos, only to be reproached by her. "This isn't enough," she told us. "What can I do with $20 pesos when I need $50 to buy his medicine?" It was an argument made with the indignation of a woman not used to begging; by a woman who felt— who knew—that she deserved better at her age. At her request, we accompanied her to a nearby pharmacy to cover the cost of the medicine. But most of the crisis's victims were far beyond our reach.

Among the most troubling cases I remember was that of Isabel Andres, then 56, a single woman fallen on hard times and whom I had interviewed inside her cozy house bought by her late grandparents a half century before. She was weak from advancing leukemia, but not weak enough to blunt her rage. She pounded her hands on the dining room table, caught between frustration and fear. In her bankrupt country, there were no funds left for people like her.

Dying of cancer of the blood, she was in need of a new drug that at the time was priced at $3,000 a month. Although her treatment was officially approved by the insolvent state health insurance system for the aged, she received a chilling reply from the woman at the service counter when she sought to collect funds to cover her medication. "There is no money," she was told. Those words became a litany for hundreds of other fatally ill Argentines. "I'm sorry, but there is no money left."

"It is just not right," Andres had said, her voice trembling. "No one thought it would ever come to this, ever. The country is broken. My God, please, I don't want to die too."

A Class Apart, A Class Destroyed
For Argentina, its large middle class was once at the core of what separated it from other Latin American nations, which have long been economically polarized, populated mostly by a vast underclass and a tiny, rich elite. But the crisis would take vicious aim at the pockets of those in the middle of the Argentina's economic strata.

On the morning of her 59th birthday, Norma González woke up in her middle-class Buenos Aires home, kissed her husband on the cheek and caught a bus to the bank. There, before a stunned teller, the portly redhead, known by her family and friends mostly for her fiery temper and homemade *empanadas*, doused herself with rubbing alcohol, lit a match, and set herself ablaze.

That was back in April 2002. Her husband, Rodolfo González, with whom I spoke two months after the incident, kept a daily vigil at the burn center where his wife was still receiving skin grafts on the 40 percent of her body that sustained third-degree burns. She had no previous record of mental illness. She had spoken to her husband and family members about the incident that morning only once.

"She just looked up at me from her hospital bed and said, 'I felt so helpless, I just couldn't take it anymore,' " González told me as we discussed the family's plight at a café near their west Buenos Aires home. "I can't understand what she did. It just wasn't Norma. But I suppose I can understand what drove her to it. It's this country. We're all going crazy."

Argentina for the past decade had been losing its middle class. A host of middle managers, salaried factory workers, and state employees lost their jobs during the sell-off of state-run industries and the collapse of local companies as Argentina blindly opened its doors to a corruption-plagued version of globalization. Initially, Rodolfo González was one of the lucky ones. An engineer for the state power company, he survived the early rounds of layoffs in the early 1990s when the company was sold to a Spanish utility giant. His luck changed when the company forced him out in a round of early retirements in 2000.

At that time, he was 59 and had worked for the same company for 38 years. Yet he landed a part-time job, and with his severance pay safely in the bank, he and his wife thought they could bridge the gap until González became eligible for social security in 2004. Then came "El Corralito."

Literally translated, that means "the little corral." But there is nothing little about it. On December

1, 2001, Domingo Cavallo, then the economy minister, froze bank accounts in an attempt to stem a flood of panicked depositors pulling out cash. By then, most banks in Argentina had become subsidiaries of major U.S. and European financial giants that had arrived with promises of providing stability and safety to the local banking system. But many Argentines who did not get their money out in time—more than 7 million, mostly middle-class depositors, did not—faced a bitter reality: Their life savings in those institutions, despite names such as Citibank and BankBoston, were practically wiped out. Virtually all had kept their savings in U.S. dollar-denominated accounts. But when the government devalued the peso, it gave troubled banks the right to convert those dollar deposits into pesos. So the González family's $42,000 nest egg, converted into pesos, suddenly became worth less than $11,600.

As the family had trouble covering basic costs, Norma González would go to the bank almost every week to argue with tellers and demand to see a manager, who would never appear. As prices rose and the couple could not draw on their savings, their lifestyle suffered. First went shows in the Buenos Aires theater district and dinners on Saturday night with friends. Then, in March, they cut cable TV.

Around the same time, the Gonzálezes' 30-year-old daughter Paula was forced to file for bankruptcy after her business—a convenience store—had failed. Separated and with two children, she turned to her parents for support.

The Gonzálezes had been planning for 18 months to take Norma's dream vacation, to Chicago to visit a childhood friend. After the trip was shelved as too expensive, she seemed to break.

"I can't explain it, and maybe I never will be able to," Rodolfo González said. He later added: "But maybe you can start to figure out why. You have to wonder: Is all this really happening? Are our politicians so corrupt? Are we now really so poor? Have the banks really stolen our money? And the answers are yes, yes, yes, and yes."

The Poor Under Siege

Even if the middle class proportionally witnessed the greatest losses, those who suffered the most were those who had the least.

Argentina's poor had long lived with more dignity than those in any other part of Latin America. But with the crisis, millions of Argentines already living on the economic edge slipped from poverty into misery. It was heart wrenching to see. Among the most emotional moments I recall from the crisis was a visit to the home of the Lugos, a family of six living in a down-and-out suburb of San Miguel just outside of Buenos Aires. It was just two days before Christmas 2001, and the letters to Santa hung on the branches of a worn plastic tree in their living room. Little Monica Lugo, a copper-skinned 6-year-old, wanted a Barbie doll. Alejandro, 12, the oldest child, was bucking for a shirt with the name of his favorite soccer team. But Mariela, a shy, bright 10-year-old, seemed to sense that somehow, things had gone gravely amiss with the family's finances that year. And indeed, they had.

The metalwork factory where her father worked for fifteen years had gone bankrupt three months earlier. Since her father lost his job, Mariela had watched as her parents sold off clothing and trinkets to buy food. Families all over Argentina were seeing their Christmas dreams shattered that year as jobs were lost, paychecks cut, and companies crumbled like stale gingerbread. Viviana Rojas Lugo, 29, the children's mother, had fought back tears each time one of her four children asked about gifts from Santa—known in Argentina as Papá Noel. On at least one occasion, Mariela had overheard her father's reassuring voice, quietly comforting her mother at night, telling her that somehow the gifts would still arrive. So the idea struck Mariela that she should ask for something different from the pricey baby doll she wanted.

"You can bring me a present if you want to, but my wish this year is just that my family will be together, and that we will be happy," Mariela wrote in her letter to Papá Noel. "That is what I want this year."

Her mother enveloped her in an emotional hug as the girl read the note aloud while I was in the Lugo's living room. "What hurts me most is that my children are losing the magic of Christmas," wept Rojas Lugo, covering her daughter's ears. "This crisis...leaves us no room for Christmas. But I don't want [my children] to give up hope, and I don't want them to blame Papá Noel. I'm not ready to give up. Not yet."

For some rural families, the crisis went far further, robbing far more than Christmas from their lives. Indeed, it had generated something rarely seen in Argentina: hunger. In the province of Tucumán, an agricultural zone of 1.3 million people, health workers reported that cases of malnutrition had risen 20 to 30 percent from 2001 to 2002. To believe it, Silvina and I would only have to visit the Orrestas.

"I wish they would cry," Beatriz Orresta, 20, had whispered to us as she looked at her two young sons near her shack in a depressed sugar cane town in the shadow of the Andes. "I would feel much better if they cried."

Jonatan, then two, rested on the dirt floor behind the family's wooden shack while Santiago, the seven-month-old, lay almost motionless in her arms. "They don't act it, but they're hungry. I know they are," she had said.

It was hard not to notice. Jonatan was lethargic. His lustrous brown hair had turned a sickly carrot color. Clumps of it sometimes fell out at night as Orresta stroked him to sleep. Santiago hardly seemed to mind that Orresta, weak and malnourished herself, stopped lactating months ago and was unable to provide him with breast milk. The infant, sucking on a bottle of boiled *mate*, stared blankly at us with his haunting, sunken eyes.

Six months earlier, however, the boys had been the loudest complainers when their regular meals stopped. Orresta's husband, Hector Ariel, had his $100 monthly salary as a sugar cane cutter slashed almost in half when candy companies and other sugar manufacturers in the rural enclave of Rio Chico, 700 miles northwest of Buenos Aires, were stung by dried-up credit and a massive drop in national consumption.

At the time we met him, Ariel was earning just over $1.50 a day, not enough for the family to survive. The peso's plunge had generated inflation of 33 percent during the first seven months of 2002, more

than double the government's projection for the entire year. Goods not in high demand, such as new clothing, had not gone up significantly in price, but staples that families needed for daily subsistence had doubled or tripled. The last time inflation hit Argentina—in the late 1980s, when it rose to a high of 5,000 percent—the unemployment rate was half the 21.5 percent it was in 2002 and most salaries were indexed to inflation. But during the crisis years, there were no such safety nets.

"I could buy rice for 30 cents a kilo last year," Beatriz had said. "It's more than one peso 50 now."

"At least we will eat tonight, that's the important thing," she had added, stirring an improvised soup. The concoction, water mixed with the dried bones of a long-dead cow her husband had found in an abandoned field, had been simmering for two days when we interviewed the family. The couple had not eaten in that time. It had been 24 hours since the children ate.

Orresta, like most mothers in her village, started trimming costs by returning to cloth diapers for her two young boys when the price of disposable ones doubled with inflation. But then she could no longer afford the soap to wash them, and resorted to reusing the same detergent four or five times. The children began to get leg rashes. By late January 2002, the family could no longer afford daily meals. A month later, Jonatan's hair began turning reddish and, later, falling out. Although he had just turned two, Jonatan still could not walk and had trouble focusing his eyes.

The story I would write detailing the family's plight, and which the *Post* published along with Silvina's evocative photos, would generate a wave of sympathy abroad that would lead to two containers of international food donations aimed at assisting the Orrestas and others in their town. But corrupt customs officials kept the stocks at the docks in Buenos Aires for months, and later raided them, taking whatever they desired for themselves. By the time what was left finally made to Rio Chico, Santiago had died.

His death, I hope, will not be in vain. My greatest hope is that his plight and those of so many other victims of the crisis captured in the pages of this book will serve as a historical testimony of those dreadful years so that we may never forget them. To be sure, the Argentine economy has rebounded in recent years, growing 9.2 percent in 2005 alone. The streets of Buenos Aires's Palermo Viejo neighborhood has even emerged as a sort of Soho of the South, a fertile hub for artists, designers, and restaurateurs. But overall, Argentina's per capita income is still hovering around $4,697 per person, almost half what it was before the crisis started.

It may take generations, if ever, before Argentina—a country I fell more deeply in love with than any other during my years in South America—resembles the nation it once was. Let us hold out hope, however, that the spirit of the Argentines can prevail and that a proud people may recover the dreams of their immigrant grandparents who sailed across the Atlantic to build one of the world's great nations. My sympathy remains with Argentina, but also my faith.

Viva la Argentina.

December 2006

Argentina May Be Down But I Don't Plan to Get Out

Santiago O'Donnell

Buenos Aires

EVEN AT ITS WORST, this is a beautiful city. It has wide avenues, European-style six-story buildings with wrought-iron balconies, plazas with statues, manicured parks. But these days Buenos Aires stinks. Every neighborhood, no matter how elegant, is littered with reeking garbage, and this is not because the garbage men aren't trying to do their jobs. It's because every night at about 10, more than 100,000 scavengers pour in from the nearby shantytowns. Hurrying to beat the trash trucks that begin their routes at midnight, they rip open and rummage through the bulging plastic bags that have been put out on the sidewalks.

Entire families come, working like military units: the mother at point, sending four or five children in different directions, the father bringing up the rear, pushing a shopping cart holding a baby or two and whatever scraps the kids collect. They rip the bags and scatter the contents because they have to work fast. These days, two or three pairs of hands go through each bag before the garbage truck arrives. Many of the scavengers look as if they once belonged to the middle class: the mother in a flowered dress, the children in Adidas sweats. But their eyes are the eyes of the hopeless poor.

In Buenos Aires, 10 p.m. to midnight isn't late—it's dinnertime, and for most of the rest of us life is going on at its usual chaotic pace. Traffic is thick, steaks are sizzling, and espressos are steaming. People like me are buying chicken ravioli at the neighborhood rotisserie, or waiting for the bus, or running for a train or a subway.

The army of scavengers descends before our very eyes, and we don't say a word. When the desperate families hurry by, we turn away. "Don't look at me, don't talk to me. I won't expect any help from you, and you won't get mugged," is the unspoken message to those who still have trash to put out from those who need it to survive.

That's how it is, eight months after our government went through five presidents in a week, defaulted on $140 billion in international debt, and devalued the savings accounts of 7 million Argentines to less than a third of their worth. That's how we deal with scavenger families, the new symbol of bankrupt, lawless, cynical Argentina: We look away and make them disappear.

Twenty years ago, when I finished high school, Argentina was a nation haunted by the ghosts of others who had vanished. These were the *desaparecidos*, the tens of thousands of citizens who were kidnapped

and murdered by right-wing and military death squads between 1973 and 1982. Some were shot. Many were thrown alive from airplanes into the ocean. Few people talked about "the disappeared" during the blood-soaked years of the dictatorship for fear of becoming one of them. Some of the mothers of missing persons staged a silent march of protest every Thursday, but hardly anyone seemed to notice.

I felt I had wasted my youth living under fascists who outlawed street gatherings of more than three people, who thought editing a school newspaper was a "subversive" activity, who banned Donald Duck from newsstands because his relationship with Daisy and his nephews wasn't altogether "proper" or "clear." Then, as a graduation present, the Class of 1982 was awarded the lead role in a senseless, bloody and deeply humiliating war over the Falkland Islands. I was doing my mandatory military service in the Argentine Coast Guard. Luckily I didn't get sent to the front, where elite British forces equipped with state-of-the-art NATO technology overwhelmed draftees like myself armed with World War II-era rifles. I saw friends and neighbors come back in wooden caskets.

When the war ended, I couldn't wait to get out of spooky, hateful Argentina.

In September 1982, I came to the United States, and I stayed for 12 years. I went to the University of California at Berkeley and to Notre Dame and the University of Southern California, then went to work as a news reporter, first for the *Los Angeles Times* and later for *The Washington Post*. I had friends and a 401(k). When I moved to Washington, I rented a nice townhouse on Euclid Street in Adams Morgan and played soccer every Sunday at a public park on Chesapeake Street, where we used trash cans as goal posts. The players included Argentine emigres from all walks of life: chauffeurs, World Bank economists, gym teachers, even, for a game or two, the ambassador.

After years of weekend basketball in California and softball in Indiana, those soccer games brought back powerful feelings of home. When a family crisis took me back to Buenos Aires, I found myself overwhelmed by the desire to stay. The ghosts of my past had pretty much been laid to rest: The generals were in jail, and the mothers of the disappeared had become national heroes. I wanted to go home, to my streets and my people and my family, to write in my own language about my own country's joys and its problems.

And there *were* problems, though they were masked by a false sense of prosperity. In 1994, the world economy was booming, "emerging markets" were trendy, the Argentine middle class had access to credit for the first time in decades and was off on a shopping spree, buying refrigerators with credit cards, new cars with personal loans, and new homes with 10- or 15-year mortgages.

I went back with my eyes open, though. From the States, it had been easy to see that Argentina was still a foreign-debt junkie with bloated budgets and closed factories, a country crippled by rampant corruption that imported everything and produced almost nothing. The government had only two ways to keep afloat—international loans and the sale of state-owned resources. The nation's oil reserves and telephone networks and prime real estate and airline routes were all privatized at fire-sale prices—and once gone, they couldn't be sold again. Meanwhile, the flood of imported products swamped regional

economies, blue-collar unemployment soared, and shantytowns grew like fungus around the big cities.

But it was home. And we Argentines are sort of used to catastrophes. At least the death squads weren't running loose and the generals weren't planning any new wars. With a glad heart, I moved back, married my high school sweetheart, got a job at a local newspaper, took out a 10-year mortgage and moved into a six-story apartment building with a black marble facade in San Telmo, the oldest neighborhood of Buenos Aires.

In America, people lose track of each other: They're born in Chicago but move to L.A., they move in and out of Washington every three or four years. In Argentina, it's not like that. When I returned, most of the friends I grew up with were still there, meeting for pickup soccer games on the same Astroturf field we had used 20 years before.

We still play there every Sunday. But lately the lives of my soccer buddies have changed. Coyote, the architect, has been unemployed for seven months now. Lucious, the chef, closed his trendy restaurant last November and now works as kitchen supervisor in a pizza chain. Pat, who owns a printing shop, is seriously considering opening a hot dog stand. Matt, the artist, moved to Chile. Nestor, who's in PR, is going to Spain next month to try his luck. Teddy, the corporate lawyer, has worked for a failed insurance company, a failed bank and a failed energy company and recently spent almost a year in the ranks of the unemployed. Rafi, the car salesman, is hoping to keep his job by making friends with his boss's son.

Everyone agrees: It's never been so bad. The recession is well into its fifth year and showing no signs of slowing down. More than half of the population has sunk below the poverty level; one out of five is unemployed, more than triple the rate of 10 years back. People who had saved money lost it when the government, trying to bail out the country's troubled banks last December, froze all savings accounts for three to seven years and converted any dollar accounts (which was almost all of them) into pesos. The peso had been worth a dollar; it was 70 cents when the accounts were converted; today it's worth less than 30, and with inflation at 60 percent and rising, lifetime savings will be worth peanuts before their owners can touch their money.

Inflation is back, like in the 1980s but with an evil new twist—today, salaries don't even try to compete with prices. At the end of the month, each paycheck is worth less than the one before, and you cut something else out of the family budget: garage parking, orange juice for breakfast, cable TV.

You take your paycheck out of the bank the day it goes in, because of course you don't trust the bank. You pay your mortgage in cash. Everybody keeps cash in the house, which has led to the latest crime trend: "express kidnappings." Early in the current crisis, people began to be stopped at gunpoint, taken to the nearest automated teller machine, forced to withdraw their limit and then let go. But now that the banks have no money, the express kidnappers pick people up, call their relatives and order them to pay, say, $200. If things go well, the victim can be free in a few hours.

This in a city that not all that long ago was one of the safest in the world.

Politicians and bankrupt businessmen grow beards and avoid the street because they are terrified of being recognized and showered with rotten eggs, which is the preferred form of heckling these days. Some who dare to go out without enough bodyguards have been publicly beaten.

After the Sunday soccer games, my friends and I talk—about our families, the kidnappings, whatever's in the news. In lowered voices, we talk about who is out of work, who is in trouble. We all worry about our jobs. Many of us think we're kept on only because of a law passed last year that says anybody who's fired during this "social emergency" gets double severance. But that law expires this fall—and besides, the laws in this country don't mean much anymore. It was three weeks after Congress passed a law guaranteeing the safety of bank deposits that those deposits were frozen and devalued.

"What are you still doing here?" my friends ask sometimes. "Don't you ever think of going back to the States?"

It's not a bad question. In a country that once welcomed millions of immigrants (including my Irish forebears a century ago), thousands of Argentines are lining up in front of foreign embassies in search of a way out. Daily flights to Madrid and Rome leave jampacked and return empty. Even the smallest towns in the most remote parts of New Zealand, Canada, Australia, and South Africa are coveted destinations. Violence-torn Israel welcomed 20,000 Argentines in the past 12 months.

Teary-eyed emigrants wait in departure lines at Ezeiza Airport here, wrapped in Argentine flags. They're sad, but they're desperate. "I can't live here anymore!" they say. "I want out!"

I know the feeling. But this time I don't want to disappear.

I could get in trouble down here for saying this, but I have to admit I like it when U.S. Treasury Secretary Paul O'Neill hits Argentines with one-liners like, "It's no use sending money down there if it's going to end up in a Swiss bank account." There were certainly things I didn't like about the States, but I miss American-style straight talk.

I get angry at many things here—the fact that good "connections" are more important than merit, the way we've gotten used to cheating and cutting corners in everything from taxes to theater lines, how we allow ourselves to be governed by the same politicians who tell the same old lies, over and over again. It's sad to see what we've managed to do to a vast, resource-rich country.

I worry that I can't leave my 4-year-old son, José, the promise of a better future than my parents gave me. There are no quick fixes for this economic disaster, I think; it will be another generation before Argentina can recover. Yet, for all the complicated reasons that human beings cherish their homes, I love this country. I have no regrets about coming back. If I'm hopeful that we may be on the verge of a long, painful rebuilding process, maybe it's just because every night more people are eating trash, and it's getting harder to look away. They won't disappear.

Published in *The Washington Post*, August 25, 2002.

Sociohistorical, Gender, and Genre Contexts

David William Foster

ONE OF THE IMPORTANT cultural responses to the return to institutional democracy in Argentina in 1983 is a resurgence of urban photography. A blend of art photography and photography for purposes of social documentary, the production of a solid group of professional photographers has undertaken to provide a new interpretive gaze of Buenos Aires, one of the major urban centers of the Latin American continent.

The point here is that photography, like all cultural production, is a translation. It is certainly a "translative interpretation" of the sociohistorical reality with which it concerns itself. But it is also bears a "translative relationship" with other forms of cultural production, into whose constellation it intervenes. I would argue that this is particularly the case when a major sociohistorical event is involved, such as the context of the Argentine "Dirty War" against subversion, the neofascist military dictatorship, and the return to constitutional democracy: it is impossible not to view any block of cultural production as not involving some degree of translative relationship to such wrenching events that dominate the consciousness of an entire society.

In the case of photography, there is certainly the visual intertexuality with film and video (both narrative and documentary, and in both big-screen and television formats) and graphic art (cartooning, for example) and painting. But photographs often tell or imply or constitute the framework for narrative, and the translative relationship with verbal narratives is difficult to ignore, which explains why a photograph (or other visual image) may often serve to illustrate the cover of a novel or, as another prominent form of narrative, a historical or socioanthropological treatise.

In sum, an analysis of contemporary urban photography—one that takes into account women's roles and issues as well as the specific semiotics of photography—departs from the premise that the photographs only "make sense" when viewed as part of the dense process of translative relationships that characterize a heightened moment of sociopolitical consciousness in contemporary Argentina.

Argentina has always been a country of photographers, and there is a long tradition of commercial, journalistic, documentary, and art photography, with the international recognition that such a production merits. In the 1990s, Sara Facio, the dean of Argentine photography and a strong exemplar of women's cultural production (if not always self-avowedly feminist) in Latin America, whose publishing operation

La Azotea, publishes many of the newer practitioners, began to curate a permanent collection of Argentine photography at the Museo Nacional de Bellas Artes.

Yet, while the work of the majority of the current Argentine photographers is available, if not always in published book form, at one site or another on the Internet, there is little in the way of interpretive academic studies. I included a chapter on Facio—her own work as well as her famous collaborations with Alicia D'Amico—in my book *Buenos Aires: Perspective on the City and Cultural Production*, and it stands as the only in-depth critical examination of her work, despite extensive brief notes, catalog presentations, and blurbs in overviews of photography. And I have attempted to contribute to the creation of a proper historical record by examining in depth the work of other Argentine women photographers like Anne Marie-Heinrich and Grete Stern (along with the Mexican Graciela Iturbide and the German-Brazilian Hildegard Rosenthal). In the case of Stern—the German photographer who was formed in the Bauhaus movement, but whose major work, especially her feminist photomontages, was done in Argentina in the mid-twentieth century—one is struck by the fact that, although there are over 1,000 Internet sites for her, she has yet to be accorded the detailed critical commentary the originality of her work deserves.

In mid-1999, the International Center of Photography in New York held an exhibit of eleven Argentine photographers, "Myths, Dreams, and Realities in Contemporary Argentine Photography," curated by Anne Wilkes Tucker. I was struck by the eloquence of this exhibit, and decided that this work could be integrated into my work on other forms of cultural production in Argentina in the context of the neofascist military tyranny (1966-73, 1976-83) and the period of redemocratization in the late 1980s.

My previous work had concerned itself with a significant amount of graphic material, in the form of a study, *Contemporary Argentine Filmmaking*, which looked at films that had been produced since the return to constitutional democracy in 1983; many of them examined issues from the period of the military dictatorship. I had also worked on the Argentine theater, which in 1981 had mounted the first large-scale refutation of censorship and the culture of neofascism. But I had focused predominantly on print culture—what is conventionally understood as literature (mostly the novel and short fiction) and, to calque a word from Argentine Spanish, "contestatorial" journalism (periodical writing that analyzed sociopolitical events from a critical point of view). I had also, along the way, published a book on Latin American graphic humor, which refers to material with a certain amount of sociopolitical commentary. All of this work—film, theater, graphic humor—included an extensive incorporation of gender and feminist perspectives.

Photography, like film, is a very public form of cultural representation, which allows it to be displayed in diverse spaces in conjunction with many other types of productions (i.e., photography as an adjunct of sociological analysis, as in the case of the Jelin-D'Amico collaboration on poverty in Buenos Aires, or D'Amico and Facio's photographs illustrating Julio Cortázar's text on the city of Buenos Aires). But the public nature of photography also means that it is easily censored, and one can, therefore, speak of a

hiatus of critical photography in Argentina. Concomitantly, one can refer to the way in which this hiatus is filled by the celebratory photography of someone like Pedro Luis Raota, who functioned as something like the official (and of course undeniably masculinist) photographer of the dictatorship.

This essay, then, is only a brief intervention in the complex and extensive history of photography in Argentina, limited to the work included in this volume and juxtaposed to accompanying feminist poetic texts. It considers the role of photography in the continuing development of culture in Argentina following the military dictatorship, the project of redemocratization, the imposition of a neoliberalist economic policy, the collapse of that policy in the context of corruption and high but officially ignored social costs, and the abiding political instability of democratic institutions. It would be foolhardy to believe that, with fully democratic elections in 1983 and the transition from dictatorship to constitutionality, Argentina's problems were solved. Indeed, they were only beginning, not because democracy created problems (of course, in one sense, it did), but rather because it allowed for a full public debate over where Argentina was in its national history and in what ways problems could be addressed. Between those who believed that a new day had come for the country and those who believed that it was business as usual, between those who believed that institutional ineptness essentially perpetuated authoritarian structures and those who believed that such structures could be adequately deconstructed, between those who subscribed to Argentina's alleged potential to be a First World country and those who believed that such triumphalism only perpetuated a hypocrisy that covered over the unimpeachable misery that failed institutional practices encouraged, and between those who felt it was more important to project an international image of a vibrant society restored and those who sensed the imperative to recognize the many social subjects who were being ignored by such projections, there has been much critical work for cultural production to address in post-1983 Argentina.

Marcelo Brodsky, for example, has used photography to participate in the ongoing debate about what has been called the Argentine holocaust: the disappearance and massacre of 30,000 Argentine citizens during the period of repression. Brodsky brings to his work the resonances for Jewish culture of a term like "holocaust," as well as the issue of remembering, which is captured in the title of his published volume, *Buena memoria*. Brodsky's work is particularly interesting because he combines print texts with photographs, his own and that of others, in order to participate in a community of critical analysis of Argentine social history relating to the repression. Brodsky is also a major participant in the project to create a "Parque de la Memoria," (memory park) and one of his roles is to assure the representation of the Jewish experience in recent Argentine sociopolitical history.

Gabriel Valansi also invests in the resonances of the Holocaust, but his emphasis lies not with identifying the period of repression as an Argentine holocaust (although he may well want to make such a claim). Rather he focuses on the way in which projections of authoritarian repression remain, as well as the way in which marginal sectors that make up the growing Argentine lower class experience social repression

through their inability to participate in the mythology of First World Argentina. If neoliberalism were every bit as devastating as the military dictatorship, its collapse has only served to increase social and economic margination. Valansi's work has not been published in conventional book form. His immense large-canvas type photographs which focus on nighttime scenes of the detritus of a fragile system contrast eloquently with the scope of those scenes. Yet these giant photographs work to insist that the reality they capture is not an insignificant detail of the nocturnal cityscape, but a major index of Argentine life in the megalopolis.

Eduardo Gil eloquently examines the hidden face of Argentine society in *(argentina)*, a title that is doubly eloquent, both by lower-casing the proper name of the country—as if it were a common noun and not the flag-waving, anthem-singing national entity—and then by suggesting its marginal quality by enclosing that name in parentheses. I use the descriptor "hidden face" advisedly, since part of Gil's project is to deal with individuals in mental institutions, many of whom are indices of the failures of a society toward its citizens, a society that then proceeds to hide them away, such that they become its hidden face. In the time-honored way in which cultural production asks us to see what we might attempt to deny, *(argentina)* asks us to scrutinize human beings made insignificant by their circumstances.

Another major way of warehousing supposedly inconvenient social subjects is by incarcerating them, and the images in Adriana Lestido's *Mujeres presas* come from a women's prison in La Plata, the capital of the province of Buenos Aires. One is immediately struck by the abjectness of these women, beyond the simple fact of their being imprisoned (for reasons never stated). Some are elderly, while others are apparently somewhat crazed or acutely alienated; many have extensive tattooing, suggesting a harsh underworld experience prior to their incarceration. One series deals with a woman forced to give her young child up for adoption. In the case of both Gil's and Lestido's photography, it is difficult to sustain any rational sense for the triumphalism of the avowals of a First World society. Moreover, one senses that the triumphalism of the 1990s in neoliberal Argentina was not all that different from the triumphalism in the latter half of the 1970s during the height of the military dictatorship. Gil and Lestido are clearly among those who sense the absurdity and the cruelty of such triumphalist sentiments, sentiments that have no truck with the human castoffs populating their sparse but eloquent photographic treatises.

Street children constitute one of the most visible faces of economic devastation in Argentina. Gabriel Díaz's *Muertes menores* includes images of little deaths, in the sense that the children he photographs experience a sort of death in small doses through economic and social marginalization that leaves them vulnerable to malnutrition, sexual exploitation, exposure, drug addiction, and the generalized abuse of the street. But these are also "small deaths" to the extent that the subjects involved are the smallest units—the children—of a society. Someone once said that you can tell a lot about a society by the way it treats its children, and one can well imagine what Díaz thinks about institutional Argentina. Díaz's most well-known photograph is of a young adolescent, apparently from the margins of the northern Argentine

provinces, sniffing glue under one of the allegorical eagles that decorates the monument of the national Congress. Díaz's photographs have a strong element of staginess about them, such that one might say he stacks the deck for maximum rhetorical effect. Yet that would be an ungenerous characterization, since a few hours spent walking the streets of Buenos Aires will reveal unstaged incidents no less dramatic than Díaz's photographs.

Another photographer who uses staged images, but in much different ways, is Marcos López. López works with color (all of the preceding photographers, except for Brodsky, work predominately in black and white), and it is often a visual universe of primary and garish colors. His intricately composed scenes have so much detail that it is difficult for a commentary to know where to begin. Although López works with a sharp sense of humor, dealing in the absurd, the ludicrous, and the hilarious, his photography also involves social commentary, as his emphasis on kitsch, on recycled cultural values, allows him to make intriguing statements about the themes and the commitments that underlie contemporary Argentine society. Like Valansi, both involve a consumerist sense and a postmodern pastiche which imply that the trivial aspects of everyday life must have a perverse sort of poetry because they lack any apparent transcendental meaning.

Finally, and returning to black and white, Gabriela Liffschitz, whose work was not part of the International Center of Photography exhibit, questions consumerist values with a radically different registry. In Liffschitz's case, it is the consumption of the female body that is at issue. Liffschitz's work is truly innovative, especially in the context of Argentine machismo, because she has had the courage to photograph her own cancerous body, its own fleshly embodiment of the devastations of modern society as they affect the individual exposed to the noxious elements of the city. Liffschitz not only exposes her own experience with cancer, but does so in a way that affirms the female body, and even more so when that body no longer fulfills the expectations of the masculinist gaze.

The assertive audacity of Liffschitz's photographs; the outrageousness of López's; the insistently testimonial nature of Gil's, Lestido's, and Díaz's work; and the long-range sociohistorical projects of Brodsky's and Valansi's complex images constitute a body of work as significant as the cultural production in others genres addressing the continuing social and political issues of recent Argentine history. Although the analyses that follow undertake to understand how the photographs function semiotically in the creation of visual meanings, they do so first and foremost within the context of ongoing processes of Argentine artists to provide a deeply critical interpretation of national life.

One will have immediately noted that, except for those who can be called historical practitioners like Facio, D'Amico, Stern, Henrich, and someone I have not mentioned, the French photographer Gisèle Freund, who worked briefly in Buenos Aires and provided memorable images of Eva Duarte de Perón, there are only two prominent women among this inventory: Adriana Lestido and Gabriela Liffschitz. Liffschitz, regrettably, did not survive the cancer whose effects on her body she photographed, but she

received considerable public attention for her work. I remember being stunned to see one of her books, *Efectos secundarios*, on prominent display in the Yenny bookstore at Ezeiza International Airport, where usually one is limited to coffee table books of photography on the most chic venues of Buenos Aires, the tango, gauchos, and the like. As for Adriana Lestido, it is important to note that she is a Guggenheim Fellow, and a Guggenheim publication subsidy allowed her to publish her extensive photographic analysis of mother-daughter relations, *Madres e hijas*. This is a distinction no other photographer of her generation has received.

I would now like to turn to the photography by Silvina Frydlewsky included in *Crisis in Buenos Aires: Women Bearing Witness* with the goal of providing interpretive comments on these images, considering them in isolation and in conjunction with the poems that appear alongside them. I will begin at the beginning, with the image on the book's cover. This photo, taken in the Café Tortoni, is subsequently paired with a poem, which I will discuss below. The Café Tortoni—located on the Avenida de Mayo near the Avenida 9 de Julio and blocks from the Casa Rosada, Argentina's Government House—evokes a rich social and cultural history for Buenos Aires. Along with the much decayed Ideal, also located a few blocks away and now mostly a tango club, the Tortoni belongs to the tradition of elegant afternoon teas, posh cocktail hours, and late night soirées. The café retains its Belle Époque elegance and is now an important stop on the thriving tourist circuit of a very much in vogue Buenos Aires, and includes a small theater space for late-night tango shows. The Tortoni evokes a bygone Buenos Aires, that of the so-called *vacas gordas* (fat cows), when Argentina was one of the strongest economic powers of the world and it was important for the elite to maintain the image of Buenos Aires as the Paris of the Southern Hemisphere. Little is left of that image and its material traces elsewhere in the city, and the Tortoni survives as a relic, as an archeological find that indexes a way of life that disappeared something like eighty years ago.

Frydlewsky's shot is organized around two principal visual references. One is a depth shot that emphasizes the cathedral-like quality of this cultural icon. The mirror at the end of the nave-like passage between tables reduplicates the outlines of the café and amplifies the rich interior of highly polished woods; marble floors, columns, and table tops; an abundant display of traditional art and photographs on the walls; impeccably maintained red leather chairs; crystal chandeliers, along with a lead glass skylight. Although the patrons do not seem particularly elegant (long into the 1960s, men were still required to wear coat and tie in such establishments), one can envision what the place must have looked like populated with the denizens of Buenos Aires long-lost café society. Indeed, the Tortoni can be read as a symbol of what Argentina once was (with all of the socio-economic disparities of that epoch), what Argentina has become (perhaps with other but no less severe socio-economic injustices), and the self-image Argentina would like to maintain, which is what drives the current tourist interest. In truth, perhaps today more foreigners than Argentines frequent the Tortoni.

However, there is another point of reference in Frydlewsky's photograph, and that is of the middle-aged woman seated at a table in the left-hand foreground. It is not clear whether she is scrutinizing someone or something that lies outside of the frame of the photograph or whether she is staring off into space. In any event, she appears to be alone, enjoying a solitary cigarette, and probably an espresso, which is also outside the frame of reference; she appears to have some sort of document before her, although she is no longer paying it any heed.

One of the major Argentine cultural motifs is the eponymous title of Raúl Scalabrini Ortiz's 1931 interpretive essay, *El hombre que está solo y espera*: the man who stands alone, waiting. Scalabrini Ortiz's essay, which references a major downtown street corner, Corrientes y Esmeralda, just steps away from the Ideal and blocks away from the Tortoni, refers to the silent, passive, blank despair of the Argentine who senses he has been excluded from the project of modernity that accounts for its much vaunted Belle Époque (and Art Deco) elegance, a project that may have forged a solid financial and political elite, a solid middle class, and considerable social mobility for the children of foreign immigrants and, later, the children of those who migrated from the provinces to Buenos Aires. Yet, something was never quite right, and this is what Scalabrini Ortiz's protagonist embodies in his feelings of socio-emotional dislocation. Of course, Scalabrini Ortiz is unrelentingly masculinist in his assessment of *porteño*[1] alienation, and one searches his document in vain for any reference to the presumed "mujer que está sola y espera."

One must turn to feminist writing to recover the stories of the other half of Argentine society. Marta Mercader's 1981 novel *Solamente ella* could well have borne as a subtitle the feminine version of Scalabrini Ortiz's now famous phrase. Indeed, the cover of Mercader's novel shows a woman posed almost exactly like the one in Frydlewsky's photograph, although she is much younger and the café in question is much humbler and more of the neighborhood variety, of which there must be thousands throughout the city. Mercader's novel carries, below the photograph in question, a publicity pitch: "Ser mujer en la Argentina, pavada de proyecto" (It's a cockamamie idea to even think of being a woman in Argentina). Although Mercader's novel charts, in a good feminist fashion, the perils of a woman's attempts at self-empowerment in the unrelentingly masculinist/machista network of Argentine society, it also speaks to the historic struggle for independence of Argentine women.

It is important to note that Argentine women—at least those of a certain economic status and often of a certain age—do enjoy a considerable range of social independence, moving visibly in the city to a degree that is unique for most of Latin America. Yet, the issue is the degree to which these women are, nevertheless, "alone and waiting" for personal fulfillment, for a measure of significant social intervention and participation, and a true empowerment that, when all is said and done, never comes. They are there, but what does that mean? What is Frydlewsky's subject thinking, where does she have to go and what does

1 *Porteño*: someone from the port city of Buenos Aires.

she do when she can no longer abide to remain at her solitary table in the Tortoni? (There is virtually no restriction on how long one remains at a table in an Argentine café.) Frydlewsky's subject may remain staring off into space at the Tortoni for as long as her male counterpart held down the corner of Corrientes and Esmeralda.[2] To be sure, a woman holding down a street corner would be considered a prostitute and treated accordingly, although today such a man could well be a prostitute.

There is, of course, an important social distinction between a street corner man (who might have ended up in trouble with the police due to vagrancy laws which were strictly enforced) and the female denizen of an elegant café. Yet the vacancy of their stare and the vagrancy of their social presence are metonymies of the Buenos Aires crisis.

The poem by Marjorie Ross that accompanies the reappearance of the photo from the Tortoni (photo 6) in *Crisis in Buenos Aires* underscores the way in which a space such as the Tortoni, while evoking a past national splendor, also, through the exceptionality of its value as a social icon, also evokes the Argentina of critical social decline. Ross organizes her poem in terms of a then/now axis, supported by the juxtaposition of past tense description and present tense circumstance. Each of the four stanzas is organized around a major theme in Argentine social history: the legendary figure of General San Martín, the Liberator of the Andes; the "Dirty War" mounted by the military dictatorship against left-wing subversion, which was often more alleged than proven; the dissolution of the boundary between European Buenos Aires and reputedly more Latin American Argentina, signaled by the province of San José to the north and Tierra del Fuego to the south; and, finally, the *corralito*.[3] Overlapping this historical trajectory are opening and closing frames that make reference to childhood and its passing. In this case the loss of childhood innocence correlates with the loss of any remaining sense of idealism by the poet for her native land. The reference to childhood is anchored in the patriotic images associated with General San Martín, but more specifically to the children's magazine, *Billiken*, which is essentially an archive of Argentine concepts of childhood and the values and beliefs associated with it for, principally, the period 1930-70.[4] By contrast, the *corralito*, in addition to the material disaster it represented to so many Argentines, is credited also by the poetic "I" with the definitive destruction of her infancy.

2 Another intertextual reference can be seen in the evocation of the Argentine café as a school for social life in Argentina, as in the tango by Enrique Santos Discépolo and Mariano Mores, *Cafetín de Buenos Aires*. Like Scalabrini Ortiz's contemporary essay, it is also relentlessly masculinist, leading one to wonder what a feminist version of this text might look like.

3 *Corralito* was the informal name for the economic measures taken in Argentina at the end of 2001 by neoliberal Minister of Economy Domingo Cavallo in order to stop a bank run. Some of these measures were fully in force for three years. The *corralito* almost completely froze bank accounts (people were only allowed to withdraw $250 weekly from their accounts) for over a year or so and forbid withdrawals from U.S. dollar-denominated accounts.

4 *Billiken* continues to be published and is now available on-line, but it no longer bears the iconicity it had in the mid-twentieth century.

As such, this is an eloquent poem about the loss of patriotic nationalism and idealism and the icons that represent such sentiments. The poem is not unproblematic because it implies the loss of the supposed privileged status of Buenos Aires. As the country's capital and largest city, Buenos Aires has always been synonymous with Argentina and with the Argentine dream of a unique modernity on the continent and the overall social and cultural benefits such modernity purportedly brings with it—thus the collapse of Buenos Aires is also the collapse of the nation. Hence, the image of Argentina as a whole bleeding to death. Needless to say—and herein lies the conjunction with Frydlewsky's photograph discussed above—we are dealing here with the feminist motif of the particular status of women as emblematic of sociohistorical disaster. If one can invest in the principle that the world is engineered and executed through male privilege and the masculinist ideology that endorses such privilege (although the men who are excluded from that privilege may "stand alone and wait") the vast majority of women, while not always and forever bereft of power, are essentially tangential to it. Thus the woman in the Tortoni, wrapped up in the solitary waiting of her lost and vacant stare, is very much homologous with the poetic "I" of Ross's poem.

Yet women constitute only one, albeit major, social sphere of the many overlapping ones that make up those sectors of Argentine society that fall (have fallen and continue to fall) outside the domains of power and privilege in early twenty-first century Argentina. One of the dramatically visible new spheres that has emerged since the late 2001 collapse of neoliberalism are the *cartoneros*. The *cartonero* is a person who gathers and sells discarded *cartón* (cardboard), and their presence throughout Buenos Aires between the early evening hours until well after midnight is one of the most striking social phenomena of recent years.

It is often difficult to know when to place the beginnings of a social movement because the root causes are often so complex that a phenomenon is more the coming together of diverse circumstances than an orderly growth from specific causes. The case of the Argentine *cartoneros*, however, is rooted in the decision in early 1991 by the Carlos Menem government to establish parity between the Argentine peso and the U.S. dollar. Prior to that time, although Argentina had had moments of economic prosperity and had competed favorably on the international marketplace, the peso had fluctuated considerably and in the late 1990s had fallen enough to seriously compromise the Argentine standard of living, especially from the perspective of the Buenos Aires middle class. That economy was based to a large extent on the ease of access to foreign goods that allowed Argentines to believe they could live more or less at the level of the First World. Parity with the dollar, which was accompanied by the slogan "Argentina is First World," allowed for an enormous influx of American and European products, for cheap travel abroad to buy these products and to consume the culture of the First World, and to sustain an image of Argentine prosperity (again, at least when viewed from Buenos Aires) dramatically different from that of other Latin American societies, including the often equally prosperous Brazil.

One of the features of the economic boom of neoliberalism that was driven by parity (never dollarization, as the Argentine peso was always maintained as legal tender, although major business

operations had long been conducted exclusively in dollars) was the massive importation of foreign goods. These goods not only displaced those produced by Argentine and other Latin American economies (resulting, therefore, in the disappearance of local industries), but generated an enormous amount of garbage: the detritus both of discarded "outdated" products as well as the trash of the packaging of imported goods (see Gabriel Valansi's photography I mention above). One of the most visible elements of this trash were cardboard boxes of all sizes and shapes, in which foreign products arrived.

As neoliberal society pursued its course—driven by economic principles that seemed to many based on science fiction rather than sound financial policies, principles that, nevertheless, a middle class that benefited most from them were pleased to subscribe to enthusiastically—there began to emerge a radical division between economic classes. This was not unexpected by anyone able to examine objectively the workings of neoliberalism, which inevitably fueled a massive redistribution of wealth, with the equally inevitable emergence of a new and rapidly expanding class of have-nots. Well before the precarious house of cards of neoliberal parity collapsed (which it did with enormous financial consequences and ensuing social violence and political instability in late 2001), Argentina was experiencing the presence of an impoverished class that was unique in its national history. This class notably included senior citizens, always a very large sector of Argentine society and one that the social security system and medical institutions no longer treated in a beneficent manner. One very public response to the descent into abject poverty of senior citizens was a rash of public suicides to protest their margination. However, those benefiting from the stridently touted prosperity hardly took notice, as they opened more and more boxes of imported goods.

The production of trash by prosperity is one of the ironies of the improvement in living conditions that prosperity was supposed to bring. Neoliberal Buenos Aires may have, in general, become more and more elegant, but the streets at night were often mini junk yards. As one might suspect, there was, ironically, a direct correlation between the quality of the garbage and the socioeconomic standing of a particular neighborhood of the city, with, concomitantly, a greater concentration of *cartoneros* in such neighborhoods. At some point, the poor began to take advantage of what was being cast off, not only to incorporate the goods discarded by the prosperous into their own life, but also to initiate an economic process whereby trash could be exploited for its exchange value. One of the most significant items in both cases was the cardboard box, which could be used as building material and which could be recycled relatively easily. Thus was born the *cartonero* phenomenon.

Today, the *cartoneros* are an organized lumpen work force. They pour into the central core of Buenos Aires, where, despite the slowing of the economy with the collapse of the neoliberal enterprise, there is still a significant level of prosperity. They encounter much garbage awaiting disposal. Typically, these individuals—men, women, older persons, teenagers, and children—come from the marginal suburbs of the province of Buenos Aires. Since Buenos Aires is a major port city, goods enter through the capital, and

much of the garbage is, therefore, confined to the central core of the city (it should be noted that not of all this garbage derives from foreign products—it is simply that foreign products brought the issue of the growth of garbage to the fore). The *cartoneros* often arrive by train, and a special train has been designated for them, not out of social concern but in order to segregate them from "decent" passengers. Made up of battered rolling stock, these cars have been minimally conditioned to accommodate the carts of the *cartoneros*. Their carts arrive and depart empty, their contents being sold at distribution points.

The *cartoneros* are not to be confused with the *piqueteros*, individuals who protest their un(der) employment and the way in which the banks defrauded them of their savings (thus, many more are middle class than the *cartoneros* are likely to be). The *piqueteros* often disrupt transmit and business, frequently in gross and disagreeable ways, while the *cartoneros* consider themselves to be gainfully employed citizens. Without meaning to disparage the legitimate causes that motivate the *piqueteros*, it is important to note that, aside from enjoying the support of some political figures, they do not enjoy widespread social endorsement in Argentine society. By contrast, considerable public sympathy has emerged for the *cartoneros*. Undoubtedly, many comfortable inhabitants of Buenos Aires are not happy to have to negotiate around this highly visible work force in the nighttime streets of the city (both Argentine café society and the large bohemian community has always considered the nighttime streets to be *their* privileged social space), but it is evident that the *cartoneros* are attempting to survive with the current economic system in an industrious and apparently effective manner. And they do make garbage collection much easier, since they themselves carry away trash that previously the municipality had to pay to dispose of.

Part of the support of the *cartoneros* has been their recognition as a valid social movement by intellectuals and artists. They are seen by many not as a passing manifestation of an unstable economy, but as an integral part of an unexpected impoverishment of Argentina that is not likely to go away anytime soon; nor are the *cartoneros* likely to go away anytime soon.

The Eloísa Cartonera publishing program is one of the ways in which the *cartoneros* have received recognition by the intellectual establishment, which has striven to provide them with acceptable visibility (Nahuel García's fine 2003 documentary film, *El Tren Blanco,* allows several of the *cartoneros* to speak in their own voice), financial underwriting for affirming the infrastructure of the movement, and, more than anything else, legitimating dignity as valued social subjects.

Eloísa Cartonera (a name that is significant in recognizing the feminine—and perhaps even feminist—component of the phenomenon) is a publishing program in which established and newer authors (most Argentine, and mostly young, although some texts are by deceased figures) donate short texts that are reproduced by photocopy. The copies are then bound in cardboard covers, which are hand painted in multi-colored acrylic. The clumsiness of this medium for lettering contributes to the unique appearance of these publications. Some fifty such publications are now in print, although only a handful has made it in to library catalogs in the United States.

This book contains numerous photographs by Frydlewsky that capture the phenomenon of the *cartoneros*. Interestingly, these photographs also function in conjunction with images of middle-class citizens, often members of the so-called *tercera edad* (the euphemism for senior citizen status). They are images in which we see such otherwise invisible participants in the prosperity of modern Buenos Aires. Through their presence on the streets they protest their descent into economic marginality, if not outright poverty. They protest individually or in groups, often assaulting establishments thought to be responsible for or complicitous with corruption leading to the collapse. On occasion, they engage outright in the imperatives of destitution, such as begging and garbage picking. These activities constitute a grim bridge between the haves and the have-nots of the urban monster.

A cluster of three of Frydlewsky's photographs support this characterization of the *cartoneros* (photos 12, 13, and 18). First, all three capture some of the most elegant sites of the city: for example the colonial church of the Recoleta cemetery area, a church where the elite of the country are baptized, married, and mourned, and buried next door at the European-style *città dei morti*. But the Recoleta is also one of the city's major museum, restaurant, and club areas, near the elegant shopping street of Avenida Alvear, which is anchored by the oligarchic Alvear Palace Hotel and is the location of the Papal Nunciate and foreign embassies like those of Brazil and France. In this way, during the nighttime apogee of the visible social life of the wealthy, the tourists, and sundry glitterati, the streets are shared with the *cartoneros* as well as the impoverished garbage pickers in general. As much as the practices of the privileged generate waste, so in like measure do those excluded from privilege avail themselves of the surplus value of what is thrown away. It is significant that Frydlewsky's photographs capture the terrible irony of the juxtaposition between the tattered appearance of the *cartoneros* as they rummage through the trash and the comfortable dress of those who participate in the night life of the Recoleta, parking their expensive cars alongside the mounds of garbage on the sidewalks, framed by the luxuriant verdancy of one of the most attractively landscaped areas of the city.

Two photographs feature some of the most elegant venues of the city (photos 12 and 19). The Teatro Colón, the Buenos Aires opera house considered to rank third internationally among such grand palaces devoted to the musical arts, is one of the signature buildings of the city. It is currently being renovated for is rededication on its hundredth anniversary, to occur on May 25, 2008 with a restaging of Verdi's *Aida*. Buenos Aires is rightly proud of such a magnificent theater, but the Colón is, nevertheless, not exempt from history. Garbage may not litter its entryway or the sidewalk around it, but it is much in evidence in the spaces outside the frame of this photograph. Moreover, the entrance faces the Plaza Lavalle (whose other architectural monument is Tribunales, the seat of the Argentine Judiciary), which, like most of the city's famous plazas, attracts the homeless and the destitute. In recent years, pensioners, who have been left to their own devices by the virtual devastation of the retirement system, have, along with others, taken to creating emergency abodes in the area.

The third photograph of this group captures the second-story café located in the public area of the Galerías Pacífico (photo 20). This extensive shopping mall is the remodeled central headquarters of the train system built by the British in the late nineteenth century and it, like many other edifices on the kilometer-long pedestrian Avenida Florida, is a monument to the Generation of 1880, which inaugurated the project of modernity in Argentina and bringing about its first boom period of *las vacas gordas*. One immediately notes the elegance of the accoutrements of the café and the comfortable socioeconomic status transmitted by the seated clients as well as the name status of the male fashion boutiques in the background. But like the Colón, the Pacífico cannot escape history. Avenida Florida is a pale shadow of its former splendor, and formidable private security agents must be stationed at each of the three entrances to control who enters the mall. Outside, the street teems with beggars, pickpockets, rag-tag performers, assorted crazies, and, in general, a plethora of individuals (local citizens and recently arrived immigrants from the provinces and surrounding Latin American countries where things are worse off than they are in Buenos Aires) who stand no chance whatever of being given access to the commercially hallowed space of Pacífico. Meanwhile, at the side and back entrances (on Avenida Córdoba and Calle San Martín), it is business as usual with the garbage upon which the *cartoneros* rely to survive. San Martín leads to the heart of La City, the main financial quarter, which is particularly attractive to the *cartoneros*, as well as to a host of individuals, including many children, who take over the streets and doorways at night.

Frydlewsky's photographic triptych (photos 18, 19, and 20; there are many other images of *cartoneros* and the down-and-out in this book), is accompanied by Gladys Ilarregui's poem, "Buenos Aires: historia del anochecer" /"Buenos Aires: Story of Nightfall." For many, nightfall is a particularly poetic time of day, with the transition it signals from the workday routine to the twin joys of relaxation and entertainment. It is a commonplace to say that a city like Buenos Aires changes character with the coming of night. This definitely applies to Buenos Aires due to the intense nightlife it has to offer, even more so now with the burst of international tourism. But the night has also always brought out some of the most unsavory elements of the urbanscape. Many would include the *cartoneros* among the latter, although as I have tried to argue above, their activities are related to survival in the city without, except in a symbolic way, interfering with the comfort of the privileged local or the tourist, whom they may discomfort with their presence but whom they do not otherwise molest.

Ilarregui centers her poem on the omnipresent bags of garbage and refuse containers to provide an aura for the city that is counter-idyllic. The poetic voice identifies Buenos Aires as "la ciudad paris," a denomination that echoes the legendary claim that Buenos Aires is the Paris of the South, while at the same time it categorically diminishes that claim. Not only is the phrase cited in lower case (and it is "paris," mockingly the French, not the Spanish, spelling), but also the syntax creates a false exocentric compound equivalent to the English "paris city"—that is, a city defined appositionally by whatever the lower-case qualifier "paris" might be taken to mean.

The poem goes on, like Ross's, to contrast a "then" versus a "now," the "then" being the elegant, "imperturbable" city of old black-and-white photographs, as contrasted with the "now" of piles of writhing garbage turned wild and murderous, driven by the devastations of a city where nightfall segues into nightmare, where the imperturbability of yesteryear is the "ira," the rage of today. The night, in the end, reaffirming its symbolic meaning that far antedates the glistening splendor of prosperity, records death through the image of refuse, "un objeto roto" (a broken object).

I would like to conclude this commentary on these juxtaposed poetic and photographic texts by returning to the urban stories of women. Another one of the images of a garbage picker involves a woman and, it would appear, her two pre-teenage children, a little girl and an older boy (photo 26). The locale is recognizably Barrio Norte, near Plaza Vicente López. We see lovely residential buildings along with mixed small commercial establishments, a typical demographic distribution for the city; there is a handsome late-model car in the background. Somehow the woman has obtained a grocery cart, and we can see her daughter sitting astride the successful pickings of the night; plastic bags containing other items hang from the cart and a large plastic bag filled with cardboard tubes leans against it. All three figures are cleanly dressed (not always the case of the *cartoneros* as their work is often dirty), and the older child is holding what may be a bag of food, perhaps recovered from the garbage.

There is no way of knowing if the woman is a single mother, although this is a strong statistical likelihood. Even if there is a husband/father also working (which could involve picking garbage elsewhere), there is no other choice for the woman but to have her children with her. While the older child may assist her in sifting the garbage, there is no escaping the fact that the nuclear family here involves, unimpeachably, a mother and her children. To trope a religious assertion defending the nuclear (and fully parentally constituted) family, the family that picks garbage together stays together. A fair number of Frydlewsky's photographs depict women in the process of sorting through rubbish, as though this were somehow a gender-determined participation in the country's economic system. I particularly liked one (photo 17) accompanied by another poem by Gladys Ilarregui, "Regina/Reina." The title not only evokes the image of woman as queen of the household (the two halves of the title are, respectively, the Latin and the Spanish words for "queen"), but also the sanctification of women's lives within traditional Catholicism by ascribing to them their inheritance as daughters of the Virgin Mary, Regina Coeli (the Queen of Heaven). This is specifically articulated by the poetic voice by insisting on how these women (e.g., the one represented in the photograph and her sisters) lack the saintly halo of the Renaissance icons. And, one might add, like the ones to be viewed in the churches found along the *via dolorosa* (painful route) that takes these queens of the contemporary *porteño* streets from one sack of garbage to another.

The book includes two images of the same family taken at different moments in the same locale (photos 26 and 27); the second one shows the mother offering food (undoubtedly pulled from the garbage) to her younger child. Additionally, there is a third image of various women going through a

large mound of garbage bags (photo 28). Again, the locale is one of middle-class prosperity, which is, as I have insisted, what generates the garbage that provides livelihood for these women.

These three photographs are accompanied by a poem by Delfina Muschietti. The poetic "I" speaks of being awakened during the night by the various sounds associated with garbage picking.[5] The neighborhood is the upscale bedroom community of Olivos, which just happens to be where the Presidential residence, with its vast private preserve, is located. There is a basic narrative concerning the privileged and private existence of the narrator, which involves generating the garbage that is subsequently, before going to bed, placed outside her residence. Once asleep, the narrator is awakened by the garbage come alive through the agency of the *cartoneros*, who produce an array of noises characteristic to the manipulation of the plastic bags, the various forms of garbage, and the (usually primitive) cart on which profitable leavings are taken away. There is an interplay among various words and phrases relating to nothingness. Garbage becomes a nothingness for the narrator by being discarded, but the garbage pickers also constitute a nothingness in their shadowy and underindividuated existence: we hear and see them for a moment, and then they are gone, moving on to another mound of garbage down the street. The interrupted silence of the night is another form of nothingness that has been interrupted by the nocturnal incursions of people from an unknown somewhere else, although the narrator perceives that the "ruido nuevo sorpresivo" (surprising and [entirely] new noise) is here to stay. Given the reference to Olivos, it would be no stretch of meaning for the poem to insist that this noise has become a permanent fixture of the placid suburban setting. And Olivos, too, cannot exist outside the history being transcribed here.

One final note: Frydlewsky's photographs are presented in lush color, quite distant in their artistic, almost hyperrealistic texture, from grainy journalistic images or those of paradigmatic documentary filmmaking, of which there is a long inventory in Argentine filmmaking (compare the gritty texture of color in García's aforementioned *El Tren Blanco*). One could even say that such heightened color here aestheticizes Frydlewsky's subjects and is, therefore, insulting to them and their struggle for survival. Yet, Frydlewsky, I would maintain, cannot be accused of monumentalizing the impoverished and the miserable in the fashion of the Brazilian Sebastião Salgado's often strongly criticized photographic canvasses. Rather, because so many of the images focus on marginal subjects surrounded by the opulence of a mythic First World Argentina, the contrast between that opulence—the streets, the architecture, the cars, the clothes, the spaces of privileged consumerism—and those who are marginalized by it is made all the more painfully obvious.

I have made much here of the continuity between women's life on the fringe because of their exclusion from the commercial and financial dynamics of their society. But it is also evident that, like the woman depicted in the cover photograph, being able to partake of privileged opulence can be chimeric:

5 See Delfina Muschietti's article in this volume on the genesis and translation of this poem. (Editor's Note)

both sectors of women are witnesses to a national crisis from which, for the time being, there appears to be no return.

Works Cited

Brodsky, Marcelo. *Buena memoria; un ensayo fotográfico / Good memory; a photographic essay.* Con textos de / with texts by Martín Caparrós, José Pablo Feinmann [and] Juan Gelman. Buenos Aires: La Marca, 1997.

Díaz, Gabriel. *Muertes menores; Minor Deaths.* Buenos Aires, no pub., n.d.

Facio, Sara, Alicia D'Amico, and Julio Cortázar. *Humanario.* Buenos Aires: La Azotea, 1976.

Foster, David William. "Anne Marie Heinrich: Photography, Women's Bodies, and Semiotic Excess." *Journal of Latin American Popular* Culture. Forthcoming.

———. *Contemporary Argentine Filmmaking.* Columbia: University of Missouri Press, 1992.

———. "Defying the Masculinist Gaze: Gabriela Liffschitz's *Recursos humanos.*" *Chasqui* 32.1 (May 2003): 10-24.

———. "Dreaming in Feminine: Grete Stern's Photomontages and the Parody of Psychoanalysis." *Ciberletras* 10 (2003): 10 pages. http://www.lehman.cuny.edu/ciberletras/v.10/foster.htm

———. "Gabriel Valansi: Neoliberal Nights in Buenos Aires." *Fisura; revista de literatura y arte* 1.3 (febrero 2003): 27-33. Also in *Significação; revista brasileira de semiótica* 18 (2002): 89-113.

———. "Homosocialism <---> Homoeroticism in the Photography of Marcos López." *Dissidences* 1 (2005): online Internet 30/0805 (http://www.dissidences/MarcosLópez.html).

———. "El kitsch argentino: la fotografía de Marcos López." *Guaraguao; revista de cultura latinoamericana* 8.18 (verano 2004): 79-101.

———. Rev. of Adriana Lestido, *Madres e hijas. Chasqui; revista de literatura latinoamericana* 33.1 (May 2004): 165-67.

———. "Sara Facio as Urban Photographer." In *Buenos Aires; Perspectives on the City and Cultural Production.* Gainesville: University Press of Florida, 1998. 170-94.

———. "Women's Society in Prison: Adriana Lestido's *Mujeres presas.*" *Journal of Latin American Urban Studies* 6 (Fall 2004): 1-18.

Gil, Eduardo. *(argentina).* Buenos Aires: Cuarto 14, 2002.

Jelin, Elizabeth and Pablo Vila. *Podría ser yo: los sectores populares urbanos en imágenes y palabra.* Fotos: Alicia D'Amico. Buenos Aires: Centro de Estudios de Estado y Sociedad; Ediciones de la Flor, 1987.

Lestido, Adriana. *Madres e hijas.* Buenos Aires: La Azotea, 2003.

———. *Mujeres presas.* Buenos Aires: Impresa Latingráfica, 2001.

Liffschitz, Gabriela. *Efectos colaterales.* Buenos Aires: Norma, 2003.

———. *Recursos humanos.* Buenos Aires: Filòlibri, 2000.

López, Marcos. *Fotografías*. Selección e introducción de Sara Facio. Buenos Aires: La Azotea, 1993.

———. *Marcos López*. México, D.F.: KBK Arte Contemporáneo, 2004.

———. *Pop latino; fotografía y textos*. Buenos Aires: La Marca, 1999.

———. *Sub-realismo criollo (fotografías color 1993-2003)*. Salamanca: Ediciones Universidad Salamanca, 2003.

Mercader, Marta. *Solamente ella*. Barcelona: Bruguera, 1981.

Myths, Dreams & Realities; Contemporary Argentine Photography. Houston: Houston Center for Photography; Pan American Cultural Exchange, 1999. Exhibit catalog.

Raota, Pedro Luis. *Faces of Life*. Buenos Aires: Escuela Superior de Arte Fotográfico, 1983.

Scalabrini Ortiz, Raúl. *El hombre que está solo y espera*. Buenos Aires: Gelizer, 1931.

Writing the City from the Crisis:
Poetic Discards, Buenos Aires, 2001

Gladys Ilarregui

Dedicated to a woman who rummaged through the garbage.
To her sensitivity and resistance.

Buenos Aires is depicted in the poetry and photography in this book as a city of impoverished people picking through the trash, anguished people unsure of their future, disillusioned people wondering what has happened to their once-proud country. Exploring a city through its contradictions and failures might not seem judicious or appealing to those wishing to cling to the image of a city in its glory with its magnificent nineteenth-century towers and Art Deco architecture. They would prefer to imagine Buenos Aires as a beautiful woman offering herself to tourists or fulfilling the longing of ex-patriots who return to visit the urban space where their reality was wed to the effervescence of their times, to the turmoil of politics, to the instability accepted as an almost normal pattern of life in that city and that country in the Southern Cone.

From the beginning, Buenos Aires, at least in the imagination of Pedro de Mendoza, the first Spanish *adelantado* sent to found a settlement, was overflowing with silver—that precious metal—an illusion necessary in the sixteenth century to take on that dangerous river, the Río de la Plata. But Mendoza's expedition turned out to be one of the most chaotic in the history of Spanish colonization. This doomed venture to establish a settlement as beneficial to the Spanish crown as those in Peru or Mexico ended in hunger, disease, and death. The two attempts to settle Buenos Aires that we know about—Mendoza (1536) and Garay (1580)[1]—communicate a sense of a rebellious order, a frequently dramatic geography on which the explorers sought to impose order by projecting on it a future city. A few lines of a poem by

1 Nuestra Señora Santa María del Buen Aire was founded by Pedro de Mendoza on January 22, 1536. One urban block was marked off and a few streets were named. According to Esther Díaz, "The first Indians found in the areas near the Riachuelo seemed friendly. But a few days after giving gifts to the Spaniards, the Querandíes changed their minds" (39). The first defeat was the result of Mendoza sending his soldiers to fight the natives, who responded with anger and eliminated half the Europeans. Also in 1536, the natives burned down Mendoza's settlement. On May 29, 1580, Juan de Garay again founded Buenos Aires, this time with the name "La Trinidad."

Fray Luis de Miranda from 1538 make reference to the hunger and the extreme conditions of the first settlement. The narrative of potential riches is subordinated to a horrifying present:

> The things seen there,
> have never before been seen nor told,
> to eat the very entrails
> of your brother (Molinari 24)

From its origins, Buenos Aires existed at the intersection of the foreign and the native, the plentiful and the scarce, and above all, the real and the mythical—the primordial element of its conception. This mythical city was the driving force behind expeditions fed by speculations that arose during the European Renaissance about the far side of the ocean. As Esther Díaz states in her book, *Buenos Aires. Una mirada filosófica* (Buenos Aires. A philosophical perspective):

> The historic city interacts through the imaginary with the symbolic city. We are, in fact, dealing with foundational myths of varying nuances. Some of these stories, such as ones from the Bible, are Middle Eastern in origin; others are Greek or Latin, and still others originated in Central Europe. But all present one or another aspect that has been reiterated in the imaginary and real construction of Buenos Aires. (68)

The Western values that shaped the colonizing ideology[2] imposed an urban horizon upon the indigenous peoples who would be displaced by a world order with different relationships between individuals and by the religious, commercial, and institutional conditions that linked the New World to European life. Within this conception of a nascent city, a second attempt to build the city was launched toward the end of the sixteenth century by emigrants from Asunción, Paraguay.[3] Weapons and horses, livestock, seeds and

2 Westernization as an ideology was a response to the Christian ideals imported to the colonies by Spain. To Westernize and to Christianize were synonymous, and this intersection reinforced the ambiguous and negative situation between mestizo elements and the native. From the sixteenth century on, official Argentine history ignored the indigenous population, its struggles and the primacy of its legacy. Westernization consistently denied the participation of women, despite the fact that women were involved in the first excursions of conquest and settlement in the Southern Cone. Very little attention is paid to these pioneer women because the cultural process of colonization was based on the patriarchal perspective of the Iberian-Catholic model wherein women occupied the world of the home or the cloister, while adventure, transatlantic voyages, and the settlement of new lands were recorded as purely masculine endeavors. See Galvez.

3 It should be remembered that Spanish women began to arrive en masse in the second half of the sixteenth century—some had already come with the first expeditions—in Asunción, where the Guaranis had offered little or no resistance. Daniel

imported tools would begin to structure economic activity. This coexistence of foreign Europe and the subalternized indigenous population generated an attitude of rejection of native elements, which would later be directed toward immigrants from other ethnic groups and especially toward the newcomers from less developed bordering countries. In the nineteenth century, the immigrants transformed existing cultural patterns, and the city became the site of new social behaviors associated with alcohol, the tango, the roughneck underground culture, and the culture imported by hundreds of Mediterranean families exiled by the war. A new cultural code would be developed in Buenos Aires based on tensions between the recent arrivals' nostalgia for their home and traditions and an autonomous "local" history that was informed by the new country, the settlement that quickly adapted to the productivity and agricultural life of its extensive pampas. Within all these cycles there was always a word that expressed the "crisis" of the city. Whether in the tango and its musical narrative or in the graffiti scrawled on the buses or in the streets, the practice of writing defined the urban sphere and reflected the complexity of its linguistic models, encompassing everything from the *lunfardo* of the nineteenth century to the Anglo-American globalized jargon of the twenty-first. One "migratory" example reflecting Buenos Aires's diversity across time can be found in Borges's literary evolution, as he went from the slums in his story "Man on Pink Corner" to the resentment of the marginalized gaucho in "The South."[4]

Balmaceda in *Oro y espadas* (Gold and swords) tells us that "the fifty audacious Spaniards led by Doña Mencía Calderón encountered the most unexpected spectacle when they arrived in Asunción. Not only was each man living with at least five native women—some had three times that number—but also it was the women who worked. They were responsible for planting, harvesting, washing clothes, and cooking, as well as satisfying the conquistadores' "other appetites" (53). Mencía Calderón was a widow and the mother of four children who dedicated herself to rounding up women in Extremadura to travel to the New World in order to regularize the men's behavior, for the Crown required the presence of women to populate the River Plate region. Asunción was a population and articulatory center and was undoubtedly comparable to Hispañola (Santo Domingo) in regard to the effort to recruit families to assure an Iberian presence and carry out the task of political and religious organization and subjugation of those lands.

4 Javier Adúriz in his article "Borges como mito" (Borges as myth) says:

> In this sense, the story "The South" is symbolic and central to the evolution of Borges's literature. Juan Dahlmann, afflicted by the destinies of different bloodlines like his creator, is also summoned by the debt of anger and the passion for books. Both destinies seem to merge at least in the dream, when Dahlmann complies with his strange mandate to confront himself through a knife duel and goes out on the vast plane to fight. It is the enmity between real life and literary life, as well as his relinquishing of himself to his dreams and literary nightmares, that resolves his entrance into the plane of the creative unconscious, as well as the death of physical heroism that signifies his ancestors, not only maternal, as Piglia . . . notes, but also paternal. (25)

I propose, on the contrary, that Borges's great revolution in this story is that he removes a figure as local as a gaucho from

In the course of Argentine history—focused on specific periods for the purposes of this article—the imported and national imaginations combined to create a complex country. This complexity is evident not only in its literature—enriched precisely by these frictions between two worlds of consumption and production—but also, and most importantly, in the search for economic parallels with countries of the First World, whose needs and capacities could not be superimposed on the reality of Argentina.

As we turn to the central theme of this article—the recent crisis—we must look at the period of Carlos Menem's government, or *Menemismo*. A clear example of emulation of the First World, this decade (1989-1999) preceded and became the basis of the ominous events of 2001 in Argentina.[5] While national industries collapsed, left unprotected by a country aspiring to become "cool" and "delivery" (a term taken from the concept of pizza delivery and used in Argentina to mean fast and efficient), the vast proliferation of malls in Buenos Aires boasted the miracle of the new without a solid base to sustain it. In his article, "Argentina, más allá del desencanto" (Argentina, beyond disenchantment), Ricardo Forster explains the problems that the fantasy generated by *Menemismo* encountered when it tried to launch Argentina on a '90s globalizing adventure. Sweeping away the past and flouting the country's efforts to consolidate its fledgling democracy, *Menemismo* created a progressive discourse that sustained itself by adhering to neoliberal models. These models created certain attitudes toward wealth and money, intensifying the traditional Argentine value system whereby social prestige is accorded based on monetary worth. The monetary unit—the Argentine peso—is loaded with symbolism. Even as it proudly displays the founding fathers, it becomes emblematic of the country's dubious struggle between resentment at the truth and entrapment in the cyclical illusion of economic currents.[6] The imposition of the neoliberal economic

his native context and infuses him with psychological and metaphysical concerns. The European man and the local man—and the contradiction in production on various levels of these two classes in Argentina—have a complicated encounter of mutual affinities and revulsions in Borges's masterly prose, a projection that goes beyond localism and achieves a new vision of fused migrations, which always generates suspicion, envy, and finally some kind of resignation or acceptance of those destinies.

5 The presidency of Carlos Menem (1989-1999) coincided with an era when elected Latin American presidents ceded or transferred public companies and national resources to multinational corporations at ridiculously low prices. Menem's neoliberalism suited the interests of a class of transnational capitalists who sabotaged any attempt to strengthen the country and acted by sending capital through the financial markets, moving funds within and outside Latin America. To this scandalous selling off of public resources and Argentina's patrimony, one must add the extravagant personality of a playboy-caudillo who hung out with movie stars, had plastic surgery, and proclaimed himself the darling of the First World through the unfettered importation of foreign products. His family was also involved in drug and contraband trafficking. Menem's legacy was the increasing frivolity of Argentine society, which did not yet anticipate the basic deterioration of Argentine capital and the sectors dependent on the country's more traditional industries. Menem controlled a highly developed apparatus of publicity and coercion that obscured much of that reality, and his participation in this corruption could be properly analyzed only years later and with the hindsight of the problems the country was facing.

6 These last paragraphs could be better understood, especially by those who have not experienced firsthand the situation in

model was a driving force behind the "crisis," the reason for this book.

One of the triggers of the protests was the *corralito*, or the freezing of private capital belonging to those with savings accounts. Translated as "playpen," *corralito* was coined to refer to the situation wherein middle-class citizens no longer had access to their money. Those who had accounts in dollars found their savings drastically devaluated overnight when they were converted into pesos. Bank accounts were subjected to statutes and regulations that seemed more and more chaotic and confused as the days passed. The final message was chaos, the loss of financial security even for those who had put their trust in the venerated Banco de la Nación. As Alejandro Kaufman says in his article "Alrededor del dinero: fragmentos sobre biopolítica" (Around money: fragments about biopolitics):

> There is no large-scale theft. This is about finances. But one must not think that this is limited to the same reasoning that makes the theft of an entire country a conquest and the removal of a square meter a theft. Property is related to possession. Now there is no possession of wealth but rather control of risk. Formerly, the risk was the possibility of becoming dispossessed. Now, dispossession occurs as part of the game. It is as if one went from formal warfare to guerrilla warfare. Risk capital is nomadic, fluid, and plays at guerrilla warfare. It does not possess, it controls; it does not occupy space, it infiltrates; it has no identity, but rather transitory and fluctuating emblems; it does not configure lineage in time or the past, but rather horizontal webs in the present and projected into the future. (84)

The ensuing fall of Menem's successor, President Fernando de la Rúa, and the succession of presidents who would last only a few hours created a climate of enormous civil insecurity not anticipated by the city whose origins were marked by hunger and disenchantment. The First World fantasy had turned into Latin American bureaucratic chaos. A president abandons the Casa Rosada in a helicopter; protesting citizens are beaten by Buenos Aires policemen, shedding their blood in the streets; the social explosion erupts with sticks swung in supermarkets and against businesses with the uncontainable force of a river overflowing its banks or an ocean without boundaries.

This extreme situation served as an impetus for the women poets featured in this book to write. They write of the experience of panic and frustration from the feminine perspective, a gender difference that translates into the ability of Argentine women to write an alternative history, alternative even to the prestige

Argentina, by seeing the movie, *Deuda. Quien le debe a quien* (*Debt: Who Owes Whom*, color 93 minutes, 2005), directed by Jorge Lanata and Andrés G. Schaer. The film moves from Washington to Tucumán to Punta del Este to Davos, Switzerland, in search of those who are responsible for local corruption at the intersection of neoliberals models. It shows the subjectivity of money in Argentina, the economic propaganda and internal agents, and the savage and astonishing poverty in the country's rural areas.

and social recognition accorded the accomplishments of men in Argentina. Women had something to say, and they said it through different channels than those traditionally utilized by men.

The participation of women was a central feature of the traveling exhibit "Buenos Aires: A Tale of Two Cities," organized by the Latin American Studies Program at the University of Delaware and the genesis of this book, as explained in the preface. A truly interdisciplinary effort that involved several departments, the Buenos Aires project included poetry, photography, and cultural and political studies within the framework of a month of conferences and other events. The pre- and post-exhibition work was nourished by a community of ideas and contributions in which these poems—within the context of the exhibit—benefited from the other creative work, all the result of the desire to show Buenos Aires, the Southern Cone, from an alternative plane, through the strength of its words.

The first source for finding this poetry—poetry included initially in the exhibit, then in this book— was through a list of women and via the Internet. These artists voice great outpourings of concern about the desperate reality of being left without savings, about the new social and political upheaval in the country. Barbara Gill's poem about ashes, featured in the brochure for the exhibit, opens what she calls "the great socio-poetic patchwork," articulated through a selection of voices not necessarily heard in the local circuits of promoted literature in Argentina. Marta Cwielong from Temperley (a suburb of Buenos Aires) said she wished to send "a little piece of a wounded nation." The women in this network communicated through metaphors that one compared to a horror movie when "you want to cover the children's eyes." Other channels were also used to solicit submissions: well-known Argentine poets Diana Bellisi, Delfina Muschietti, and Ivonne Bordelois were invited to collaborate, as well as Argentine poets living abroad— Zulema Moret and Silvia Tandeciarz in the United States and Cecilia Rossi in England. As often happens in collections and anthologies, the selection criteria for the poems included in this volume emerged out of specific intersections, themes, urgencies, and approaches that lend themselves to artistic treatment. Those poets who participated understood the particular spirit of that moment, the coming together of factors: the popular movements, the incoherencies of state power, the press and its loose ends, the multitudes, and marginality.

The poems gave voice to the unrest of the populace. While the poorest sectors of society expressed their sense of impotence by breaking shop windows and participating in massive demonstrations, on December 19 and 20 of 2001, the middle class mobilized with *cacerolazos*, or pot-banging, a phenomenon treated by Analía Bernardo in her contribution to this book. Popular frustration was expressed through this emotional release. Just as the term *corralito* (playpen) evokes the image of controlling a baby's free movement, so the *cacerolazos* invite one to consider women as a referent, as an agent of change. The *cacerolazo* was a movement that engaged many social classes. As those with frozen bank accounts launched their protest against the banks, the poorest sectors quickly learned that their fate was going to be even worse when they lost their jobs in small businesses and other workplaces whose stability depended on

the damaged middle class. Although this does not fully explain a very complex reality, the Buenos Aires formerly characterized by its splendor was emerging into a disfigured present and an even grimmer future. The values represented by the founding fathers—a heroic past and the promise of a glorious future—lost all meaning as citizens roved the streets at night looking through garbage bags for scraps. Discards.

The exhibition of poetry at the University of Delaware was created through that image of cast-offs or discards.[7] Discards came to be the referential concept of the crowds gathered in different areas of Buenos Aires to partake in their nighttime meal. It was shocking to think of the hunger described by the first settlers of Buenos Aires in the sixteenth century and to discover that many centuries later our daily life contained such rituals, rituals of injustice regularly acted out on the sidewalks of the best neighborhoods of the city. Santiago O'Donnell, in his article contained in this collection, defined it well: it was a new scenario within which were developing other micro-worlds, such as the *cartoneros*—cardboard scavengers—and their derivatives,[8] the folding and the unfolding, as Zulema Moret says in her poem "X", of their anguish. Thus emerged a sample of a larger movement: poetry went out into the streets, leaving the museums behind and playing an important role in the articulation of the new reality. This poetic expression laid bare the root cause of the problems, zeroing in on the fine thread of the local language and all its resources in order to arrive intact at that precise instant when a universally shared truth takes expression.[9] Francine Masiello comments on this phenomenon in the chapter entitled "From Museum to Street: Poetry for the

7 Gérard Wajcman, in his book *El objeto del siglo* (The object of the century), maintains that the object of the twentieth century is ruin: "Broken glass, fractured dishes, scattered food. This birth of *ars memoriae* is a disastrous still life—perhaps the still-life genre was also borne, long ago, out of this" (16). Wajcman works with this concept of ruin and extends it to the ruins of war and concentration camps. Although ruin and refuse are different concepts, it is interesting that neither manages to create a whole. They are both a part, a scrap, a fragment of that lost whole that is, nonetheless, loaded with meaning.

8 In his essay in this book, David William Foster makes reference to the *cartoneros*, a complex movement that enters cultural production from the street to the bookstores through Eloisa Cartonera, a press whose books were exhibited at the University of Arizona. Poetry in particular found in this publisher an alternative aesthetic refuge, as is evident in the titles that are still being published in Buenos Aires.

9 As I write these words I realize that I am still basing my thinking on the concept that there is a split between writing poetry and "living in the world." The carry-over of this idea into the twenty-first century shows how slow we are to changing our habits of reception, even among academicians. For Latin Americans in particular, to name poetically is to name politically, and texts by authors such as Juan Gelman, Pablo Neruda, Ernesto Cardenal, Claribel Alegría, Gioconda Belli, and Diana Bellisi clearly exemplify a broad consciousness that poetic language, its synthesis, and its registers serve the goal of better identifying daily failures, limited alternatives, the moment of refuge from public memory through personal work. Of course, this order of discourse does not respond well to mass marketing—not even within the university and especially not after the phenomenon that De Certeau calls "cultural in the plural." In any case any good anthology will be a unique and accurate mirror of its time, like Carloyn Forché showed in her global collection, *Against Forgetting. Twentieth-Century Poetry of Witness*. This essay is based on the idea that the most domestic word and the most familiar objects can find a public, and political, voice.

New Millennium" of her book *The Art of Transition: Latin American Culture and Neoliberal Crisis*:

> Yet, what form can poetic language take at the start of the new millennium? What can poetry be allowed to say? And what happens to the course of experimental poetry when claimed by writers whose lives are defined beyond institutions and canons, most specifically by contemporary women? Women's poetry returns to history and identity, to experience and representation. Far beyond the speculations offered by some proponents of critical theory, poetic discourse in the hands of women opens to a different critique, tracing memory as it is etched in sound and speech, linking popular and elite traditions, reminding us of the somatic effects of geography and politics on the fin de siglo gendered body. (222)

The poets discussed below write within this current. I begin my discussion with a poem by Diana Bellessi, an author whose preoccupation with the nation is reflected in her poetry, particularly in the collection *La rebelión del instante* (Rebellion of the moment). In the section "Notas del presente" (Notes from the present), hunger, the grocery story, and life on the street are treated in Bellissi's highly personalized style with the question that dominates the poem: ". . . If not I, if not you?":

> So long ago and you said
> who will speak about these years
> if not I, if not you, I knew
> just now the deep-down
> meaning of those verses
> and I say I don't know
> what to do with it though I feel
> urgency and feeling such
> as you had, my dear and admired friend,
> back in the seventies. (71)

This poem refers back to the Argentina of the mid 1970s to early 1980s, buried in silence by the military regime, with its well-known history of kidnappings, repression, and torture. The author clearly needs to think about those moments in relation to the present, the social problems, the needs and identities shaken up by the deterioration. Another fundamental work in which Bellessi addresses the misery of this "new" Argentina is "The Cities Speak:"

Bunches of small
bluish stars
spill spells
into the night of La Plata

Paradises are the
wretched wealth
that safeguard the suffering
of those who seek

food in the rotten
garbage that now
is treasure in the streets
of La Plata. (86)

The collecting of garbage for personal survival was a recurrent presence in the photography exhibit. This rite of poverty allowed words to transmit images that seemed utterly improbable in a place where the modern, the new, and above all, the creative—the abundance of concerts, movies, theaters, workshops in psychology, philosophy, and art—still represented some kind of irrefutable proof of the existence of the cosmopolitan city, whose intellectual activities had not vanished even under the censorship and fear of the 70s. In her analysis of the evolution of Argentine poetry written by women, Francine Masiello addresses the role of memory and tradition:

> The consolidation of women's poetry marks a special feature of the recent decades. Gwen Kirkpatrick observes a veritable "explosion" of women's poetry starting in the late 1970s, in which women rewrite myths and transform expressions of collective memory (1989, 132); Diana Bellissi insists on the rise of women's poetry as the decisive mark of Argentine literary culture of the 1980s when she claims that women offered the literary establishment a "mixture of erudition and savage originality" (1986, 149). Ironically, she adds that women constitute a *lobby* as if to parody the way in which the neobaroque poets had announced a lobby of their own. (227)

Bellessi's poem "Death by Hunger," included in this book, is almost a hymn in its portrayal of the indifference to hunger in the midst of "obscene abundance." Approaching language from a different

perspective,[10] Ivonne Bordelois's words create an architectural structure in a poem that describes the city of Buenos Aires through metaphors of decadence within the recent historical-cultural framework. The text presents a denunciation of the devastation and of the arrogance of the leaders. The lexicon evokes degradation, dishonor, and filth:

> This city, abandoned, suicided
> Asks that her worms, her flies, her serpents be cleaned from her
> Asks that the mother's apron, the grandmother's diadem, the queenly walk,
> Be returned to her.
> Asks that the beautiful fire of indignation
> Glow once again in the sky over her river.
> [translated by Sergio Waisman]

Disgust, one of the feelings mentioned in the poem, conveys the idea of discarded—refused—food that is transformed into food cherished nightly by the poor. The idea of refusal and the eagerness for these discards converts the garbage bag into a political node. It seems impossible for there to be any kind of satisfaction, compensation, or joy at finding pieces of fruit, scraps of meat, or crusts of dry and moldy bread that can appease hunger in the stench and cold of the night. And it is a moral, civic, and political fact that these same displaced human beings awaken more than compassion or "discomfort" when they visit the city like concealed animals that must take possession of the "wealth" thrown out in those bags. William Ian Millar, in his book *The Anatomy of Disgust*, discusses the connection between disgust and hatred:

> Disgust and hatred also overlap in some of their variations. The principal connection arises out of the concept of aversion, which carries with it not only the mixture of hatred and disgust but also the form in which they reinforce each other. Disgust brings to hatred its special way of manifesting itself, the form in which it is presented as disagreeable to the senses. (63)

Delfina Muschietti makes references to the "other side," to the woman poet who awakens while this scavenging is taking place outside. The poetic "I" understands that there is an "almost" that cancels the

10 Ivonne Bordelois has formal concerns about language. She received her Ph.D. at Massachusetts Institute of Technology, studying under Noam Chomsky, and as a result of her linguistic training, has developed her interest in etymologies and her analysis of discourse that is sometimes at odds with a more casual use of language. Regarding her work with poetry and translation, it is worth reading the letters she exchanged with Alejandra Pizarnik in the now classic book, *Correspondencia Pizarnik*.

possibility of encounter with that humanity, unless one chooses and accepts a poetic encounter wherein aesthetics—understood in its most traditional models—divide and disarticulate, and the text then becomes a rupture between the "inside" where the family sleeps and an "outside" where an unpublished chapter of post-*corralito* Argentina is being written:

> I wake up in the night
> not long asleep
> 12 am
> a rustle of plastic bags papers
> cardboard, eggshells (again Pasolini!)
> a russ-russ that purrs
> at the front door
> almost beside my window
> almost
> inside where we all sleep each one
> in their own bed
> > [translated by Delfina Muschietti and Cecilia Rossi]

The most interesting aspect of this searching—digging in the garbage, claiming as one's own what belonged to another among these cast-offs—is the task the authors themselves formulate by employing everything from pathetic realism to Cecilia Rossi's grand lyricism. One of her poems, "City of Gold," is bathed in light and invites us to see the summer sun playing in those streets of Buenos Aires. In a delicate melding of darkness and light, the poem weaves together the two realities, the diaphanous and the chaotic:

> If this were not what it is—
> the daily rummaging through rubbish
> in the open seams of the city's streets—
> It'd be bright light, of gold
> > [original in English]

In her second poem in this collection, the author speaks about the "city's yield" in that urban sphere in which paper, cardboard, and glass—the cubic centimeter of garbage for "a new breed of farmers"—are collected, setting in motion a powerful lyricism in reference to childhood:

> Let's put it this way:
> If the children are saplings,
> come spring, sun, rain,
> will they turn trees?
> [original in English]

Zulema Moret, in contrast, approaches the city through action, with the strength that characterizes her poetry in exile. Her poem creates an urban moment of a great act, almost like a daily show or a production line, the automatic and efficient folding and unfolding and the moral and political implications:

> That plague
> That pleat
> That deployment
> Of ev-er-y-day
> Pain
> Something
> About asphyxia
> About the unsustainable
> [translated by Sergio Waisman]

Silvia Tanderciarz chooses in her search for horror to return to the experiences of the seventies during the period of the military dictatorship, when, for example, *escuelita* or "little schoolhouse" signified a concentration camp. Two of my own poems are also included in this section. "Buenos Aires: A Story of Nightfall" evokes San Telmo and its heroic past, memorialized by its postcards of the port found in the open-air market where antiques and collectibles are sold to avid tourists. All of this transpires in a chaotic and impoverished panorama with contrasts of dark and light. "Reina/Regina" speaks of two humanities, each with their own semiotic referents, one for those trying to lose weight and one for those who, with wounded, filthy hands, rummage around among containers—once intact and squeaky clean in the supermarket—that offer contents with fewer calories. Even in the printed word on the garbage, in the chemistry and fusion of marketing strategies, two palpable cities emerge.

Finally, it is important to give full recognition to the women who can be found only on the Internet, women who can come from any context, and who, in a deeply moving way and almost like a postmodernist game of Lego, use national symbols and traditions. Betty Tosso incorporates the national anthem, transmuting it through a sequence of concepts that builds on the sentiment expressed by Ivonne Bordelois in her poem discussed above—that of "occupied country/city" taken over by the unscrupulous politicians

and their incapacity to create some sort of social order:

> Phoebus illuminates the historic
> thieves
> the corrupt
> murderers
> cowards.
> [translated by Sergio Waisman]

This is the national anthem turned on its head by the words of a woman who belongs to a civil society shaken by the devastating collapse and by those moments of political instability. These words resonate with memories of banks choked with people, of long lines around the block to demand—to still demand—the money taken ransom by the government, of the suicides, of those insane episodes when people entered banks with gun or grenades and threatened the tellers. Memories of the burning of businesses and other symbolic objects on many street corners. Betty Tosso's poem dismantles all those clichés of glory: that nineteenth-century pride in a country that welcomed immigrants, that hosted celebrities in the vast countryside, that boasted the best harvests of wine, corn, and Argentine beef, the fine grain of its leather. The author does away with all that failure in a surprising way, recovering a unique personal discourse within this symbolism: "I am a coward, I remained tied to the mast. And I know why."

Marjorie Ross travels back into Argentine history toward the great heroes of the process of independence, such as General San Martín:

> When I was a girl
> Argentina
> was General San Martín
> galloping heroically
> through the pages of *Billiken*.

Billiken was an illustrated magazine for young children that taught them history, stories, and songs; it is part of Argentina national heritage. Similarly, children learn about San Martín from the earliest grades as an example of patriotic integrity and sacrifice. Taking the concept of childhood full cycle, Marjorie ends the poem with an allusion to her lost innocence in the context of the situation in 2001:

You know,
with the *corralito*
my childhood
left me
too.

[translated by Sergio Waisman]

Olga Drennen speaks about a "state of death" when describing a family reunion; Valeria Flores invokes "the empty plate/at the edge of history;" Marta Cwielong describes an afternoon in Temperley as "this twilighting August day/sheds tears of blood." Barbara Gill moves us with her metaphorical play of daybreak and ash. The fistfuls of ash will mold a "new Motherland" which, in an affirmation of gender, the poetic voice maintains "will have to be nursed."[11] Finally, the short prose piece by Analía Bernardo describes (in the fashion of Breton) a pot or pan (the *cacerola*) as a vision of the domestic and the personal. In that house that is society, women march to demand their suppressed rights for hours on end, banging that object that is used to prepare food. The *cacerola* in Argentina was the background music for hours of marches in the convulsive city, music that created a multifaceted scenario during those days of chaos.

On more than one occasion when reading these contributions, I have been reminded of contemporary Greek women poets, their confrontation with history through words, with dictatorship, repression, and the uneasiness of living in uncertain times. The verses of Jenny Mastoraki, in the collection *Greek Women Poets*, return to me with particular intensity:

I don't know what I would've done
if things hadn't turn out
this way.
I might've written
history books
for the third grade. (58)

While this essay discusses how poetry was inspired by the crisis in Argentina, I do not wish to imply that the poetic word requires hostile or unstable conditions to flourish. The fact is, however, that in these

11 Some feminist theorists might have problems with this affirmation, with this attempt to deconstruct the traditional cultural representations about women, but as Cecilia Secreto sums it up in her essay, "Herencias femeninas: normalización del malestar" (Feminine inheritances: normalization of malaise) in Cristina Pina's *Mujeres que escriben sobre mujeres (que escriben)* (Women who write about women [who write]): "Women, when they write, take back the realm of the imaginary through the maternal myth of the corporal, the poetic, the undifferentiated" (167).

dire circumstances Argentine women expanded their capacity for struggle and their sensitive observations of the complexity of the social situation they were living. Does this collection constitute an example of an aesthetic current? My reply would be no. I would say that the selection emerges out of a vocabulary, a self-revelatory discourse borne out of a political moment. It was created out of different energies and voices, all conveying a subject matter that impacted and pained women working with words on many different levels. I would like to add that with such a generous process of contribution of poems we did not aspire to poetic exemplarity, but rather looked to the verbal and metaphoric outlines that brought that reality into existence, exposed it, and condemned it to the page.

The writing of discards was important not only in order to read the street in a poetic register but also because it provoked an extraordinary response in the readers—students, professors, members of the community—who visited the exhibits in Delaware. The poems hanging on the walls with their English translations on the same page were read as if they were a long Chinese calligraphy. People read and walked, made comments, listened to these writings from a distant land like clusters of anguish, clusters of the present. More than one thousand readers experienced the beautiful and sad city through the words of these women poets.

Several creative channels were opened through this project, including a staging of the poems by the graduate students in Spanish at the University of Delaware. A teachers' workshop examined ways in which images and words could be used to explore other issues in their communities. In the exhibition one could see in action the synthesis of poetry and the images captured by Silvina Frydlewsky, inviting one to take a trip and experience cultural ideologies and traditions,[12] to become emotionally involved with that country in the Southern Cone, with that rich, but poor, city. The rebellion, the frustration, the fear, and disdain of these women poets in the face of daily injustices all found a conduit for immediate diffusion, accessible at diverse levels of curiosity about and familiarity with Buenos Aires and its crisis. All the poets had taken an extraordinary voyage into history.

What remains is to trust that art is not an ephemeral exercise, that through art—any manifestation of art—we can speak more effectively about the world we experience and that through our voices, we can undo

12 It would be interesting to mention here what Diana Bellessi said in an interview conducted by Alicia Genovese and María del Carmen Colombo. When they asked her about her book "Sur" (South), she responded:

I feel that part of the United States is also the south, Hopis and Navajos also constructed my imaginary lineage and represent cultural resistance to what appears as the central theme. Within this resistance come together other excluded groups. The north has its own south. Also because of the Southern Cross, because it is the star of the manger, again it points to the rebirth of a little light over the world, the ideals that do not die after so much terror and so much death. (*Colibrí 186*)

This exhibit also sought to approach these North/South disarticulations, to open paths of encounter through the pedagogic use of the poetic word.

the darkness of incommunication. To trust that we become mediums for others through the reflection of our splendor and our sorrows; that somebody, in that gallery filled with poems and photographs, could feel a human being going into the street to look for food in the garbage.

Translated by Katherine Silver

Works Cited

Adúriz, Javier. "Borges como mito." *Hablar de poesía.* 5.III (2001): 20-32.

Balmaceda, Daniel. *Oro y espadas.* Buenos Aires: Marea, 2006.

Bellessi, Diana. *Colibrí lanza relámpagos.* Buenos Aires: Tierra Firme, 1996.

———. *La rebelión del instante.* Buenos Aires: Adriana Hidalgo, 2005.

Díaz, Esther. *Buenos Aires.Una mirada filosófica.* Buenos Aires: Biblos, 2001.

Forster, Ricardo. "Argentina: más allá del desencanto." *Pensamiento de los confines.* 11 (2002): 43-54.

Forché, Carloyn. *Against Forgetting. Twentieth-Century Poetry of Witness.* New York: W.W. Norton & Company, 1993.

Fourtoni, Eleni, ed. *Greek Women Poets.* New Haven: Thelphini, 1978.

Galvez, Lucia. *Mujeres de la Conquista.* Buenos Aires: Planeta, 1992.

Kaufman, Alejandro. "Alrededor del dinero: fragmentos sobre biopolítica." *Pensamiento de los confines.* 11 (2002): 77-85.

Masiello, Francine. *The Art of Transition: Latin American Culture and Neoliberal Crisis.* Durham: Duke University Press, 2001.

Millar, William Ian. *The Anatomy of Disgust.* Cambridge: Harvard University Press, 1998.

Molinari, Ricardo Luis. *Buenos Aires: cuatro siglos.* Buenos Aires: Tea, 1980.

Pina, Cristina. *Mujeres que escriben sobre mujeres (que escriben).* Buenos Aires: Biblos, 1997.

Pizarnik, Alejandra. *Correspondencia Pizarnik.* Buenos Aires: Planeta, 1998.

Wajcman, Gérard. *El objeto del siglo.* France: Verdier, 1998.

Translating the Experience of the Crisis into Poetry

Delfina Muschietti

THE FIRST THING I see is a woman in a summer dress, a cooking pan in one hand and its lid in the other. Her glasses hanging from her neck and a somber, pensive look on her face, she stands in a deserted Buenos Aires street at sunset. She is the first to arrive at the street demonstration, one of the many that took place during those days of December 2001 when the people united to alter the political fate of Argentina and make a government fall. That was the photo that impressed me the most of those displayed in the exhibition "Buenos Aires: A Tale of Two Cities." These pictures were taken by another woman who knew how to capture the combination of hopelessness and energy in this woman as she waited for others to arrive to fight for the same objective. I couldn't help but think of those other women, the Mothers of the Plaza de Mayo, who succeeded in bringing down one of the most violent dictatorships of Latin America. Like the white headscarves that became the symbol of the Mothers, so the pots and pans of the 2001 demonstrations became emblematic of this struggle. Without weapons, with cooking tools, these women waged a peaceful fight until they changed the destiny of a country.

For these reasons when I was invited by the University of Delaware to take part in the event, I felt compelled to accept the challenge put before me. For the first time in my career as a poet, critic, and translator, I had to write on a given, pre-determined subject: the socio-cultural and economic crisis that shook Argentina and caused the angry protest of its people. But where would I start? No doubt about it, the crisis that had started in the previous decade was now unmanageable, its effects spreading from the poorest to the richest of neighborhoods, extending beyond the city's borders. Echoes of spectral visions from interior provinces reached us in Buenos Aires: entire families loosing their homes and jobs, wandering through the streets, going through the garbage looking for food as thousands of people suddenly became *cartoneros*,[1] homeless, finding shelter in the doorways of shops or on the benches at the train stations. How would that reality translate into poetic form?

1 Derived from "cartón" (cardboard), the word "cartoneros" emerged during Argentina's crisis to name the people who try to survive selling pieces of cardboard salvaged from the garbage.

I. The Creative Process: Philosophical and Theoretical Considerations

I've always believed in the notions Arthur Rimbaud deemed crucial for modern poetry: memory, desire, and perception. From there, the main issue should be: "To find a language."[2] As Derrida points our, the important task is to find a *formal quantity* that insists on the re-appropriation of language, which is, from the very beginning, the language of the other. In other words, it is a return to one's motherland, a territory which does not exist.[3] It is thus a paradoxical work paralyzed by the contradictory aspects of passion—love and suffering. As in the tradition of all modern poetry, I found myself doubly committed to the body as resource: on one hand, I was paralyzed on the edge of perception where poetry communicates with an outside, connected with the mnemonic traces, leftover words, and sensations organized in the memory as a substrate of subjectivity; on the other hand I found myself listening to the subtle whisper of words emerging from the single body in order to organize them into some object-form on the blank page. Between the two extremes, the poem's language should be found, a language capable of communicating the experience of desolation, a collective experience suffered by an entire country trying to find its words from the *remains-made-flesh* of an individual suffering body.[4] It was necessary to purge myself to hear the language of my body and to then begin a series of translations and its *derives*[5] until the written poem emerged on the page. However, the body is also the axis of numerous cross-translations that soften the sharpness of certain perceptions; it is the body's amnesia that emerges from the empire of oblivion. It is against this oblivion that the poem fights, the subject of our next section.

Thieving the Theft of Oblivion[6]

If twentieth-century poetry addresses the empire of oblivion, if the voice of poetry is the voice of the dream, and if we can argue that the *locus* is the body, it means that poetry paradoxically tracks the remains of a twice-missed body[7]: a body expropriated by death, and expropriated and disciplined by culture's language. But the dream state is also recognized as the closest to that of childhood:

> [O]ur dreams are a means of conserving these successive personalities. When asleep we go back to the old ways of looking at things and of feeling about them.[8]

2 "Trouver une langue" in the French original from Rimbaud's letter to Paul Demeny, May 15, 1871.

3 See Jacques Derrida, *Monolingualism of the Other, or the Prosthesis of Origin.*

4 Judith Butler calls this process "embodiment." See her *Gender Trouble - Feminism and the Subversion of Identity.*

5 Derrida's terminology of deconstruction.

6 See my book *Más de una lengua: poesía, subjetividad y género.*

7 See my article "Leer y traducir: restos y robos melancólicos."

8 Havelock Ellis (1899), quoted by Freud in *The Interpretation of Dreams.*

The dream contains archaeological spheres that speak in another language about an already phantasmagoric body. Like a zoom-in, the dream opens the exploration of the zone of our memory that Freud calls "the archaic," which only reaches us in fragments and traces, and is never complete. From *The Interpretation of Dreams* (1900) to *Beyond the Pleasure Principle* (1926), Freud deems translation the main mechanism by which the body and self relate to the outside world, where language performs as an intermediary or filter.

In this way, the volume of our memory is a translation of a history developed outside the limits of our body, whose perceptions and sensations of that history remain as a fragment attached to some form of language. Our memory is the history of those fragments in our body. As Octavio Paz, Walter Benjamin, and Freud himself note, every translation transforms the original. Therefore there is always something lost and something enlightened in the process. The broad spectrum of sensation, based on the rich plasticity of experience, is reduced when it reaches the limits of language and meaning. The dream is one of the devices that the body counts on to recover the greatest sensorial wealth offered by perception, when the deafening effect of the diurnal impressions stops, as Schopenhauer tells us. That is why the dream narrative becomes the material for an infinite number of possible readings. There are always other senses that evade us in every reading of the dream, attempts in vain to recover the lost sensorial experience. The dream, like literature, proves itself to be resistant to a solitary and closed reading time and again.

As Freud explains, the dream state is linked to an underground memory that has been stolen/removed[9] from our capacity/ability[10] to remember during the day while our disciplined conscious memory keeps our eyes open. Freud's concept of the dream state bestows great power to the unknown force that ensnares our memory. Theft and Oblivion define us during our waking state, while the dream starts an uncontrolled dispersal of memory with its trivial and useless details.[11] The language of dreams is "hieroglyphic" for Antonin Artaud, who endeavored to achieve its form in his art. As Derrida contends, Artaud's most astonishing experience was to verify that the *spoken word,* the "breath-souffle" word,[12] spills out of the body. This word is dictated by language or culture to my body, a word that is always stolen, never my own. Derrida tell us that to speak is to hear oneself: when I hear myself, the other speaks. Language, concludes Derrida, emerges in the prototypal structure of theft and expropriation. Alluding to the spillage of words out of the

9 robado/ sustraido in the Spanish original. (Translator's note)

10 capacidad/ facultad. (Translator's note)

11 "Details" also prevail in poetry composition as Russian Formalist Iuri Tinianov pointed out. See his *El problema de la lengua poética.*

12 Translation of "la parole soufflée" in *Writing and Difference.* Derrida's translator preferred to retain the original French phrase due to the difficulty in translating "soufflée." The word "blow," he noted, would introduce another semantic field. For the same reason in our text we use a composed expression: "breath-souffle."

body, Artaud signed letters with "I am The Stupid Deceived Antonin Artaud."[13] Signature is then, as stated by Mallarmé, the inscription of a disappearance and the Book-Text, a tomb.

This language paradox echoes the paradoxical nature of death as formulated by Martin Heidegger in *Being and Time*: "Death is the possibility of the sheer impossibility of being-able-to-be-here. Death thus reveals itself as the ownmost, unrelational, unovertakeable possibility. As such it stands before Da-sein in a *preeminent* way" (King 152). Following this formulation, Artaud's conception reveals that the body is no more than a sign or mark of expropriation—a missed body, stolen since birth, "as if being born has for a long time smelled of dying."[14]

Arturo Carrera reiterates this paradox in *La partera canta*[15]: "la muerte mana del bebé ciego al aparecer" (death flows from the blind baby just born). Thus Carrera rewrites Artaud's image of a body that starts to die at birth; broken by absence, a body alive and dead at the same time.

One of Artaud's poems enacts the dematerialization of the body:

Il fait très froid / comme quand/ c'est/ Artaud/ le mort/ qui/ souffle.[16]

The "f," the "rr," and the "t" are syncopated in the first line, and then plummet into the continuum of the second line and into the almost non-existent whisper of the third, only to reappear in the name ARTAUD, a signature that stresses the R and T. This pairing reappears in MORT which virtually dematerializes the following QUI. It is as if the remains of the subject are volatized by the SOUFFLE, a breath which captures the frigid air of the first line ("Il fait très froid"). The frozen halitus of death, the inscription on the living body, speak in the breath of the poem. Even the syntactic and lexical expectation that announces the predictable phrase (*c'est Artaud qui parle*) is undermined by an alteration (*Artaud/ le mort*), and a substitution (*parle* for *souffle*),[17] which does nothing but affirm the imminent disappearance.

This archetypal alienation flows from Artaud's poem-body to the blind baby just born of Arturo Carrera and persists in Alejandra Pizarnik's murdered little girl: "La infancia implora desde mis noches de cripta" (Infancy cries out from the nights of my crypt).[18]

13 See Artaud, *Lettres à Génica Athanasiou* (our translation).

14 Quoted by Derrida in "La parole soufflée," *Writing and Difference*.

15 The title of the book is very difficult to translate into English. "The midwife sings," the literal meaning, misses the word play between *parto-partera-partir* (labour-midwife-to leave and to divide) all derived from the same root in Spanish. Another consideration is that the "partera" is a traditional, strong female figure in Spanish culture, the experienced woman who helps deliver a new baby into the world. So the opposition life-death is highly marked in the Spanish title of the book.

16 "It is very cold as if the spirit of dead Artaud were blowing in the wind" (translation ours). Alejandra Pizarnik's Spanish translation of this Artaud poem was published in *Sur, 1964*.

17 (Artaud speaking), (Artaud/the dead man), (speaks for blows).

18 Poem published in Pizarnik's *Extracción de la piedra de la locura*. "The dead little girl" is the center of the gender story that Pizarnik develops in her poetry. In this figure we can see a duplicitous body, both alive and dead, of life being breathed

However, the process of poetic creation is about forms of illumination, forms of truth that show us a body fascinated by its own division—the place where it reads culture's inscriptions and where it also announces the dream of shapes to come, the blind baby just born, illuminations or spectral inscriptions that poets endeavor to rewrite as they read. As if the language of dreams could be acquired, Artaud insistently pursued the impossible: the rejection of the language-structure of expropriation and the creation of that other hieroglyph that speaks with the mute and untranslatable language of dreams.

The stolen body-word brings the original theft closer to the act of translation. Translation and theft are frequently found in Derrida´s readings of Artaud, in Deleuze's repetition and difference,[19] and in Freud's considerations of the passage from the dream state to wakefulness and back. In this translation, we witness the loss of the physical body within the body of language, whose domain is Sense and Meaning, the auspices of Metaphysical Culture. Because of its specific ability to inscribe itself upon the materiality of language, poetry tries to retrace its steps and recover its lost carnality, in the interest of Sense and Concept. Similarly, acting as the body's refuge, the poem tries to recover the loss that occurs in the transition from dream to dream narrative. But then it translates backwards again, activating Derrida's concept of *more than one language*[20], in the imminence of another language to come.[21] The poem, like the translator, attempts to transfer fragments into a dreamlike form, with its liberated disposition and uncontrollable economy of unfolded memory. It is all about a passage from form to form, from *formal quantity* to *formal quantity*.[22] To compensate, the dream recomposes and modifies the fragments that arrive from experience, similar to the process whereby translation modifies the language of the original through the language of the translator. Poetry thieves from the thievery of oblivion with vividness and accuracy of detail, rhythm, and sonorous cadences, allowing us to return to the sensations seemingly lost forever. Poetry fixes the unfixable and makes visible the invisible. That is its impossible task.

What poetry shares with post-metaphysical contemporary philosophy seems to be philosophy's principal figure: the paradox. If poetry is the most refined expression of the condition of language (as Heidegger, Derrida, and Paz pointed out) it is simultaneously the unfolding of its paradox: nothing is translatable; at the same time, translation itself is inevitable. And, as a further paradox, poetry joins the stillness of signs with the movement of meaning triggered in language. In its composition, poetry joins velocity to contemplation's intensity, infinite multiplicity to unity. Thus, poetry synthesizes that very particular condition of language itself: that it is never isolated, always in translation, and open to the

into a dead body as a consequence of the colonization of culture. See my article "Alejandra Pizarnik: la niña asesinada," also Judith Butler, cited above.

19 See Gilles Deleuze, *Difference and Repetition.*

20 See Derrida, op cit.

21 See Sylvia Plath's considerations on the process of her own writing in *The Unabridged Journals of Sylvia Plath.*

22 See Derrida, op cit.

imminence of other languages. "Translation," notes Octavo Paz, "suppresses the differences between one language and another (but at the same time) reveals them more completely."[23]

The poem, as we have noted, retraces while pressing forward: thieving the theft of oblivion. The poem is composed on the tip of the tongue that articulates an ever-moving limit, reaching the borders of language (the dream, the unraveled memory), and returning to communicate both the body and its other—an operation that plays out both the excess and the loss due to the robbery. The poem's theft becomes excessive, an expansion that speaks to the impossibility of reaching a motherland that does not exist: an impossible journey to *one's pre-first-language*, which is only a phantom promise to recover the lost flesh plundered by oblivion. Consequently, the direction of imminence promises a language of return which is actually a language of arrival. It reminds me of Alfonsina Storni who retraces the canon and reinscribes it with more languages: ironic, self-parodying, and self-translating. Language's property is created at these extremities, where poetry illuminates a particular experience that points to areas invisible to hegemonic culture—another form of thievery of the theft of oblivion. Thus, "thief" and "madman" are terms used to label the speaker, removed from the economy of reproduction, in Pier Paolo Pasolini's "Un matto senza madre" ("A motherless madman").[24] This same thief will contemplate the loss of the dream in "Le belle bandiere" ("The beautiful flags") by wondering: "What is the morning dream telling me?"[25]

The poem shifts its attention to the sound produced by the dictating voice of the breath-souffle, writing on the edge of the body, on the page. Suddenly, language, as a foreigner to itself, far from its property, is embodied in the crease of closed eyelids. It comes from the world of sensation and must be translated with minimal difference to the abstract world of sense. It opens and closes, sleeps and awakens, records what is heard in the silence of images. It is read from language, stretching and pulling language beyond the surface of its furthermost limit, beyond the fold that communicates with the Utopia experienced in transcribing the dream.

It is utopian because being awake is to be in language and to belong to its expropriation, to *the death economy*. Writing poetry is a way of returning to the impossible realm of dream. Appearance or surface, film or limit, the eyes or the body articulate my relationship to the world. As Pasolini says, "tutto il mondo é il mio corpo insepolto" (the entire world is my unburied body) with the breath-*souffle* of great revelations. Denial's cold breath simultaneously delays the moment of burial, persistently uttering *no*, and resists what is still alive as a result of this same denial. My body, as Pasolini says, is confused with the world (*corpo-mondo*): my body is the limit of the world, or the world is possible because I still perceive

23 Octavio Paz, *Traducción: literatura y literalidad* (our translation).

24 "Un Loco sin Madre" in my translation of Pasolini into Spanish, Pasolini, *La mejor juventud,* 31-32.

25 Pasolini, *La mejor juventud,* 80.

it, guided by the contact with each of my senses through the openings on the porous surface of my body. The apparent equation—*corpo-mondo = corpo-non morto*—could be read as *morto* signifying the end, chained and castrated, of *corpo* and *mondo*—the moment in which burial returns them, indivisible, to earth or dust. But, simultaneously, *tutto*—implying entirety—is completely possible because the negation is in the present, affirmatively resisting with its nothing, with its breath of absence. In English the words are fused through the internal vocalic rhyme and the repetition of "r." The "b" in *unburied* also breathes life into the "b" of *body*. We thus substitute the link between the pair *corpo-mondo* with the link between *entire-unburied* in the English translation to allow the *un*-denial to continue to work by cutting off the materiality of the word's body. Poetry oscillates between the mere affirmation of the insistent materiality of the word and the mere absence of silence, made present in the sonorous intermission, the absolute spectral body that shines like that which is desired by the poem.

The translation is then in its origin more than one language, working in poetry as the passage between the poem's language and the other worlds that open their languages to translation: nature, dream, sensation, experience, memory, and other texts. The insistence moves from microscopic to macroscopic, from intimate to public, like the light that completely illuminates the Thief of Pasolini at the end of his poem. If translation points to the "untranslatability" of a work, as we said following Walter Benjamin, the poet is the translator who prepares for a return trip that communicates body, world, and dream—in other words, a roundtrip. The poem returns to retrace its steps along the forward path that leads to the body's materiality and thieves the theft of oblivion as it tries to reach a dream state, a state which is much grander and more profound in its sensitive consciousness than in waking life as Freud pointed out in *The Interpretation of Dreams*.

Poetry, then, is like a succession of failed translations. In those failures, like a game in the abyss, it finds its excess, its theft from the empire of oblivion. If, at last, poetry tries to reach perception, the sensitive world, and thus restore language's thieved corporality, it must merge the path of return with passage through dream. In this way, the dream lends the poem a form of freedom that the poem translates while simultaneously revealing the impossibility to translate it. It is a form that is always "unclosed," accessible to the path toward the imminence of other languages, following the impossible trace of a lost body.

II. Genesis and Creation of the Poems

The Altered Bodies of the Crisis

Great historical changes, crises, and revolutions are also times of great changes in perception for man, as Benjamin attests when he explains the shock produced by the domestic use of the match and the transit

of carriages on ill-prepared streets of nineteenth-century Paris.[26] The crisis that we Argentines experienced in 2001 brought into our everyday lives powerful new sensorial stimuli which forced us to acquire new perceptive habits. These new stimuli became part of the collective memory, they became intertwined with other areas of the past, connecting with our individual subjectivity. I resolved to start with this phenomenon when faced with the challenge of writing poems about the crisis from a woman's perspective, to make the poem work against the almighty oblivion.

The first new scene that commanded my attention was the unfamiliar sound that awoke and startled me every night at midnight. I live in Olivos, a residential neighborhood in the northern zone of greater Buenos Aires. My house is old, built in 1930, and, surely, my high bedroom window in this Spanish-colonial style home had never before witnessed the scene that took place every night in the street below. Here we keep the garbage container where we throw our *basura* (garbage): leftovers, eggshells, useless papers. In Spanish "basura" is the same word we use to talk—with great indignation—about a person who is hurtful and unscrupulous. It is the same word we use when we consider something to be useless and we have to get rid of it.

It took me some time to realize that the same nightly sound was repeatedly waking me when I had finally managed to stop worrying about the many changes effected by the crisis and fell asleep. The sound was like a russ-russ of papers and plastic bags that went on for a couple of minutes, reaching my ears through the window, soft but persistent in the darkness. It came from outside and deprived me of sleep; it took hold of me and shook me back to reality. Freud is right when he says that hearing is the only sense that is constantly running, the one we can never shut off or close as we do with our eyes, a weak but unalterable link to the outside. The stimulus was persistent in its arrival and my conscience awoke, my body shook in the presence of a new experience that it could not decipher and that altered my sleep. I then understood that the noise came from those phantasmal families beginning to inhabit Buenos Aires when the light of day was extinguished: men and women who had lost their jobs and their homes, and wandered outside with their children at night, looking for something that that we had discarded as useless—something to be taken from the trash in order to survive. They didn't talk; they just rummaged through the rubbish, in silence, a painful ritual. It was then I understood that this new detail I had perceived and that was anchored as a mnemonic sign to the repository of my memory was the beginning of the poem that had been waiting for me to fight against oblivion. It was necessary to find its *formal quantum*.

From the outside to the language-sign the first attempt at translation had occurred. The persistent sound had come from outside and had brought me completely outside of myself, translating the language

26 Benjamin, "Paris—Capital of the 19th Century" 77-88 and *Charles Baudelaire: A Lyric Poet in the Era of High Capitalism.*

into few words: desolation, families who had fallen out of the system, homeless. Curiously, the English word "homeless" forcefully accompanied the new sound. Another translation was needed to elevate the words to the powerful aesthetic of the poem, where they are stronger, more powerful through the articulation of the rhythm. I decided to let myself be guided by the sound that condensed the situation and allow it to translate itself through the passage of contiguous spheres.

This is the final version of the poem that arose from this new sound:[27]

me despierto en la noche
recién dormida
son las 12
ruidos de bolsas de plástico papeles
cartones cáscaras (siempre Pasolini!!)
un frus frus que ronronea
en la puerta de casa
casi pegado a mi ventana
casi
adentro donde dormimos cada uno
en su cama
después de cenar
después de cerrar la bolsa con los
desperdicios restos *trash* sacarla
a la puerta como todas las noches
dentro de los dispositivos adecuados
garbage dicen en inglés
en la vereda afuera
la familia busca y rebusca
en eso que llamamos cotidianamente
La Basura
van con un carrito y acoplan nada
sobre nada
-no estábamos acostumbrados
es un ruido nuevo sorpresivo
pero vuelve ahora cada noche

27 English translation of poems provided below.

es un desgarro
imaginarlos ahí afuera
frus frus
dale que te dale sin descanso
afantasmada la carne
adelgazada la vida
nada sobre nada
de los cuerpos
en el aire inmóvil
de la noche de Olivos
nada
sobras
nada

Pasolini's echoes have tended to appear in all my writings after I began to translate his poetry with great passion in 1995. His word has remained an incandescent trace in my hand at the moment of composition. This is translation's powerful effect on the translator: we seize the words we read and transfer them into our own flesh, thus making them re-emerge as a fabric that enables us to read similar realities. When I decided to make the russ-russ sound of the garbage play the most important part in scene, the image that came to me was Pasolini's poem describing another place of the Third World—the poem in which he travels through Africa looking for Christ's face in order to make the film "Il Vangelo secondo Matteo" ("The Gospel According to Matthew").[28]

The aesthetic strength of Pasolini's poetry remains in my memory. Anchored in the body's fibers, a similar stimulus made it resound. "The Gospel" paints a scene of poverty produced by another group of young people disinherited by capitalism. Its reference to Algerians as "Condenados a muerte" (condemned to death) echoed in my head together with this list: *papeles-basura-postes-cajones de madera (carte-rifiuti-pali-cassette di legno* in Italian, *papers-trash-posts-wood boxes* in English). The impression of signs, words I had chosen to translate the description of the poverty of another Third World country—and the "arena negra" (black sand) as the background of that scene—were calling me once again in the night in Olivos. Pasolini's poems that I had translated had returned to translate poverty's marginality. The poverty I had

28 Here is Pasolini's poem in my Spanish translation: "Una rambla. Luces blancas, rotas./ Viejos empedrados, grises de humedad tropical./ Escaleritas, hacia la arena/ negra; con papeles, basura./ Un silencio como en las ciudades del Norte./ Aquí, muchachos con blue-jeans color carroña,/ y remeruchas blancas, ajustadas/ sucias, caminan junto al parapeto/ (....) /como argelinos condenados a muerte/ unos muchachos más jóvenes; postes, cajones/ de madera, una manta, extendida sobre la arena negra." Published in *La mejor juventud*, original version in *Poesia in forma di rosa,* 1964-1966.

never experienced with such proximity was now an evening ritual at the steps of my house. Entire families that had been marginalized from "normal" citizen life like my own: a boundary had been crossed by dark political manoeuvres, my family on one side, sheltered, sleeping in "normal" bedrooms while others were lost in the cold of the night, like ghosts, lost in the sound of the violated trash cans, leftovers of emptiness. That dissolution dictated the end of the poem, evoking the remains of *nothingness* with rhythm and sounds. That *nothing* could have been ours, I thought. There was no reason to explain why we had been placed on this side of the frontier. Suddenly, another image that was firmly inscribed in my memory sprung forth: that of the young girls, aged four to ten, who pressed around us in the subway and the trains, selling holy pictures, filthy from a life on the street without beds, food, or a table for the family meal. I remembered those little faces and another stab of pain overtook me, another dagger to the heart: and what if my daughter were the one on the other side of the divide?

Second Poem: The Original Version
pasea su futura amnesia
infantil
y su shock anestesiado
desvaído
por los trenes de Retiro
por el subte cavernoso
que la abriga de ese frío
mi hija ¿y si fuera?
ojos brillantes piel bruna
4 o 5 años esbeltos
con su estampita roñosa entre
los dedos
mi hija, ¿y si fuera mi hija?
qué vértigo sube cuando
se piensa
cuatro años expuestos
a cualquier mano de hombre
o muchacho
sin doblez de sábana
sin leche
la boca abierta para recibir
el golpe

desnudo y la sangre llena
que desborda el labio
el sexo aún no nacido
¿y si fuera Eugenia
alguna otra vez en otra vida
perdida de familia
sola
sin genealogía
de abuelas tías primas
yirando por la calle
a los cuatro años
desvalidos
y yo aquí inmóvil
sin poder nada?

I decided to focus on the image of one of those girls selling the fiction to hide her poverty. Repeating the same phrase over and over again, imprinting her face on that of my daughter at that same age was a painful but enlightening exercise in view of the injustice which was no fault of our own, yet implicated us as citizens of a society in crisis. It was an exercise of solidarity that needed to be expressed in poetic form, and allow the reader to experience the strong emotions that we lived every day, the same emotion we were all feeling as we imagined our own daughters in the place of these young girls in this devastated and devastating place. It was not only about the inability to satisfy their basic needs, but the fact that they were defenseless, exposed to disease and sexual abuse. Therefore, the poem was also focused on gender: a woman who writes about a girl's destiny, about a girl who is trying to survive beyond the human limits of existence. Now, as a reader of my own poem, I see how it prefers the use of feminine words, words that conclude with *a*, words that also paradoxically show the girl's lack: *futura amnesia- bruna- llena (la sangre)- otra vida- sin genealogía*. Capturing the gendered implication of the words was to become one of the main difficulties in translating the poem into English, a language without gendered words: *future amnesia- brown- full (of blood)- some other life- without genealogy*. The accumulation of those a-words culminates in *nada* (nothing), the same word that ends the first poem. *Nada* is opposed by *llena* (full), but the latter is also presented in a negative light, associated with profuse bleeding instead of with plenitude. Other powerful terms associated with the feminine gender are *roñosa* and *yirando*. The first one, with its concluding *a*, has an intense feminine presence because its root word is *roña* meaning dirt, mange, violence,

fight, anger, in the street language of the tango, *el lunfardo*.[29] The second word, *yirando*, is equally intense because it comes directly from *lunfardo* and is associated with prostitution (prostitute is *yira* in *lunfardo*). *Yirar* is also the verb for the streetwalking of the prostitute in search of clients. The word used in the poem is in the present participle: *yira*ndo.[30] This word anticipates the future of these girls, what they will be exposed to in the street due to their poverty and indigence. At the moment of composition *lunfardo*–as the language of marginalization—continually whispers to me the words of daily life in Buenos Aires.

The Difficulties of Translation into English[31]

The second challenge started at the time of the third translation. The poem, written in Spanish—in Argentinean, or more precisely, the Spanish of Buenos Aires—had to be translated into the English. It had to convey to the foreign observer that in these moments of crisis a new border had been erected, dividing the city into two sectors: those who were within the system and those who had fallen out of it. The visual images of the photographs were powerful vehicles of that experience. This was more difficult to express in words because they required translation and, as Benjamin says, there is always something lost between the original language and the one of arrival. Translation is all about working through that loss or "mourning" as Ricour calls it, following Freud.[32] It was "mourning mourning," then, to translate the poems of the crisis. It became important to re-compose the phantom of repetition into the poem in English. Following Benjamin, the challenge was in capturing the tone, the *manner of speaking* or its *manner of repetition* of the original, so important in the cadence of its respiration. Translation proposes to preserve the importance of the repetition of sounds because it was the motivating spark of the scene and would later be articulated by the reader. That was why Cecilia Rossi and I decided to choose English words that would reproduce the echoes of that sound when they fell one over the other on the tongue of the speaker.

29 *Lunfardo* emerged as a special vocabulary in Buenos Aires at the beginning of the twentieth century when massive European immigration brought about a demographic change. The resultant urban poverty contributed to the establishment of prostitution in "conventillos," places where words created from traditional *gauchesco*, Italian, and French, began to circulate. Some of the words also originated in the world of crime while others were linked to the "*malevos*" and the tango. Borges used to refer to this world in his texts as that fascinating sphere that was inaccessible to his condition of a writer from a traditional family of Buenos Aires. After this period, *lunfardo* crossed the border into everyday life of *porteños*, those who live in Buenos Aires. However, it has always been linked in some way to low society and is still frequently used by the poorest people of the city. While not accepted in school, universities, or formal situations, it is part of the intimacy of daily life for *porteños*, especially among male friends and young people.

30 The word also recalls the famous tango "Yira, yira," related to the extreme poverty produced in Buenos Aires by the crisis of the '30s.

31 The poems were translated into English by Cecilia Rossi in collaboration with Delfina Muschietti.

32 Paul Ricoeur, *Sur la traduction*.

The First Poem in English Translation

I wake up in the night
not long asleep
12 am
a rustle of plastic bags papers
cardboard, eggshells (again Pasolini!)
a russ-russ that purrs
at the front door
almost beside my window
almost
inside where we all sleep each one
in their own bed
after dinner
after closing the bin bag full of
rubbish leftovers trash taking it out
placing it by the door like every other night
inside the proper receptacle
garbage they say in English
in the street outside
the family searches and rummages
about in what we always call
La Basura
they push a small cart and pile nothing
upon nothing
-we weren't used to it-
it's a new sound, surprising
but now it returns every night
shocking
to think them out there
russ-russ
without rest over and over
their ghost-like flesh
life thinning

nothing upon nothing
in the still air
of the night in Olivos
nothing
left
over
nothing

We kept the words which were in English in the original—*trash, garbage*—as they are words from a language heard daily by Latin American people through films, television series, and song lyrics. American English interferes with our everyday language, and the same invasion happens with Spanish in the lives of American citizens in big cities. But there is a difference in that English signifies for us a sign of First World power while the reverse is true in regard to what Spanish means for the English speaker. Besides representing an exotic kind of world, the Spanish language is associated with the poverty and marginality of many Hispanics living in the U.S. That is why it was so difficult to maintain that interference and difference in the translation. The word "garbage" in the original could no longer capture the reference of the relationship between the U.S. and Latin America, so we finally choose to leave the Spanish word "La Basura" which is used in our daily life as the term for the garbage.

At the end of the poem it was very important to keep the word *nada* and to manipulate it spatially—*nada* above (*over*) *nada*—to highlight the sensation of extreme lack. That is what we try to do with the final stanzas: "nothing/ left / over / nothing." After experimenting with different arrangements we decided to keep each word alone in the stanza to mark the paradoxical importance of *nothing,* omnipresent in its void. The other difficulty was how to translate the neologism "afantasmada" which appeared in the original to allude to that condition of emptiness that even affected flesh, turning people's bodies into phantoms at night. We translated it as *ghost-like flesh* in an attempt to recover the visual image of "afantasmada carne." In the next line we had to transform the past participle "adelgazada" which refers to the action of getting thinner (losing weight, in this case because of hunger) into a present participle—*thinning*—the best possibility we were able to find in English to indicate the process of getting lighter. The Spanish rhyme *ada-ada* is lost but we attempted to respect the relation between sounds in another part of the poem—in the *f* of *flesh* and *life* which are firmly united in sound and sense. They refer to materiality's loss of density due to the devastating effects of the crisis on the bodies of the city.

Second Poem: The English Translation

1 **she** walks **her** future infantile
2 amnesia
3 and **her** anaesthetized shock
4 blurred
5 on the trains of Retiro
6 on the cavernous subway
7 that shelters **her** from the cold
8 my daughter, what if **she** were?
9 shiny eyes brown skin
10 4 or 5 slender years
11 with **her** grimy holy print
12 between **her** fingers
13 my daughter, what if **she** were my daughter?
14 a vertigo rises when
15 one thinks
16 four years exposed
17 to the hand of any man
18 or boy
19 no folded back sheets
20 no milk
21 **her** mouth open just to receive
22 the blow
23 naked and thick blood
24 that bursts **her** lips
25 **her** sex not yet born
26 what if **she** were Eugenia
27 another time in another life
28 lost from family
29 alone
30 without the genealogy
31 of grandmothers aunts cousins
32 walking the streets
33 at four

34 helpless
35 and I here unmoving
36 with power
37 to do nothing?

In the second poem, as we said, the recurrence of the feminine gender turned out to be an important issue at the moment of translation. In Spanish there are few pronouns that clearly refer to a feminine third person. The possessive "su," for example, is used for both genders, while in English the possessive "his" or "her" marks a clear difference. As a result, the English version has a stronger feminine voice (note the many feminine pronouns, indicated in boldface), while the Spanish is much more subtle despite its references to the gender of the scene's young female protagonist, its feminine voice. On the other hand, the Spanish text insists on other feminine-specific terms which are not so directly related to a person: in the –a endings or feminine words like *sábana-sangre llena- vida- familia- genealogía*. The last *nada* (nothing), as noted above, brings together all of those *a* words at the end of the poem.

Another interesting problem results from the preposition *por* after the past participle *desvaído* (*anaesthetized* in the English version) that not only gives meaning to the space through which it passes but also serves as a preposition for the agent of the past participle in Spanish. In English one can give priority to one of the two meanings—*on* or *by*—thus eliminating the ambiguity of the expression.

In the eleventh line, "grimy holy picture" tries to translate an image that doesn't exist in Anglophone Protestant culture: *la estampita*. This card is an icon for Catholics, who use it to pray to the Virgin Mary, Jesus, or the saints. Poor children sell those cards for pocket change to the passengers in trains and subways or in the stations.

In lines 22 to 24, the translation plays with a number of metonyms that we try to maintain from the original, although they are transferred to a new place in the translation. The scene suggests a form of humiliation of the girl's body. However, *desnudo* is paired with *golpe* and *llena* with *sangre* (and not with *boca*) when the regular order would be "*the mouth full of blood because of a blow.*" It is clear to us that slowing the perception of the object intensifies the work of art, as Russian Formalism alleged. In English, *naked* is also an adjective modifying *blow* and *thick blood* becomes another attribute of blow, creating a repetition of sound. Instead of the original two syntactic centers, we have a single one in English, linked to the other with magnetic attraction (*blow-blood*). With this construction we also achieved a sonorous conjunction (*blow-blood-bursts*) which was not present in the Spanish version and which recovers, in a way, the loss of the two centers by gaining synthesis and intensity.

In line 32, we sought a suitable translation for the *lunfardo* word *yirando* and the connotation that it bestows upon the figure of the girl. It means to meander down the street in a neutral meaning but can also imply that this meandering is done by a prostitute, the anticipated future of the girl due to her marginality

and poverty. We decided that the best term was "walking," which can also evoke the "street walker."

The last word of the poem, the meaningful *nada* (*nothing*) dominates the composition with its sense of deprivation. I recall Sylvia Plath's poetry with persistent use of "nothing" and other negatives words, her lines resonating in my head: "I am guilty of nothing." "I am Nobody." "I was seven, I knew nothing." "I am none the wiser." "I am myself and this is not enough." Her poetry emerges as another illumination of lack in human existence, and more particularly as a notion of feminine gender built on negation. This recognition of an identity based on void or deficiency is necessary in order to begin to deconstruct the oppressive power relationship that brought it about and construct a new, positive identity.

With my poems I intended to follow the path traveled by Plath, who could go beyond the confessional, intimate plane of certain scenes to expose an entire cultural construction and political work through domestic relationships (*father-daughter-mother-sons, husband-wife*). Similar to my translation of Pasolini, as I translated her work I tried to make her rhythm reverberate in my own composition. I have found in both Plath's and Pasolini's poetry a powerful *formal quantum*, that acts (has the potential to act?) as a promised land. For that reason I sought a path in the details of the memory of my perception that would lead me to compose poems that reflected the verses of Plath and Pasolini as if they had appeared upon the scene in Argentina, driven by a music, by a rhyme, by the explosions of color and sound. As if their words echoed in the profound crisis that unsettled many of our prejudices and, even in our pain, helped us to see things from another horizon.

Translated into English by Valeria Meiller in collaboration with Meghan McInnis-Domínguez and
Delfina Muschietti

Works Cited

Artaud, Antonin. *Lettres à Génica Athanasiou*. Paris: Gallimard, 1969.

Benjamin, Walter. *Charles Baudelaire: A Lyric Poet in the Era of High Capitalism*. H. Zohn, tr. London: Verso, 1983.

———. "Paris- Capital of the 19th Century." *New Left Review* 48 (1968).

Butler, Judith. *Gender Trouble: Feminism and the Subversion of Identity*. New York: Routledge, 1999.

Carrera, Arturo. *La partera canta*. Buenos Aires: Sudamericana, 1982.

Deleuze, Gilles. *Difference and Repetition*. Paul Patton, tr. New York: Colombia University Press, 1994.

Derrida, Jacques. *Monolingualism of the Other, or the Prosthesis of Origin*. Palo Alto: Stanford University Press, 1998.

———. *Writing and Difference*. Alan Bass, tr. University of Chicago Press, 1978.

Freud, Sigmund. *The Interpretation of Dreams.* New York: Penguin, 1992.

King, Magda. *A Guide to Heidegger's Being and Time.* John Llewelyn, ed. Albany: State University of New York Press, 2001.

Muschietti, Delfina. "Leer y traducir: restos y robos melancólicos." *Filología* 33-34 (2006).

———. *Más de una lengua: poesía, subjetividad y género.* Buenos Aires: Biblos, 2005.

———. "Pizarnik, la niña asesinada." *Filología,* 24: 1-2 (1989).

Pasolini, Pier Paolo. *La mejor juventud.* Delfina Muschietti, tr. and intro. Buenos Aires: La Marca, 1996.

Paz, Octavio. *Traducción: literatura y literalidad.* Barcelona: Tusquets, 1990.

Pizarnik, Alejandra. *Extracción de la piedra de locura.* Buenos Aires: Sudamericana, 1968.

Plath, Sylvia. *The Unabridged Journals of Sylvia Plath.* Karen V. Kukil, ed. New York: Anchor Books, 2000.

Ricoeur, Paul. *Sur la traduction.* Paris: Bayard, 2004.

Tianianov, Iuri. *El problema de la lengua poética.* Buenos Aires: Siglo Veintiuno Argentina, 1972.

La pequeña voz del mundo

Diana Bellessi

[Fragmentos]

1.

Esa pequeña voz del sueño o de la vigilia más atenta que la idiota de la familia escucha, los ojos fijos en la gloria de las formas. Intenta traducirla con las mismas herramientas inocentes del vulgo. Pero la engola a veces, la encierra y no deja a la grácil melodía fluir por donde quiera. Esa pequeña voz que escribe los poemas. Quién, si no ella, podría decir nadie se baña dos veces en el mismo río. Arcaísmo sutil de un pensamiento que no desea ir mucho más allá de la ofrenda o la celebración de diminutas revelaciones repetidas siempre, una y otra vez sobre la huella de la conciencia humana. Pura emoción que se traduce, se enfría como condición ineludible del recorte y vuelve a llamar, con fortuna, por gracia de resurrección sonora a cuyas ancas sentidos y significaciones se tejen como jaez que permite la monta del caballito flameante.

La voz del poema, la voz que el poeta cree su voz. Su condición de vanguardia consiste en ser retaguardia, vigía del fondo, tragafuegos que se funde con la última silueta anónima del cortejo de la feria. Ella lo sostiene, desde lejos, desde atrás, y lo impulsa a ser la cresta. Fondo y figura moviéndose fugaces bajo el tambor del corazón.

Las tareas de esta voz: permanecer atenta a lo inútil, a lo que se desecha, porque allí, detalle ínfimo, se alza para ella lo que ella siente epifanía. Las tareas de esta voz: deshacer las cristalizaciones discursivas de lo "útil" y tejer una red de cedazo fino capaz de capturar las astillas de aquello que se revela. Atención y artesanía. Las tareas de esta voz: desatarse de lo aprendido que debe previamente aprenderse, y disminuir así los ecos de las voces altas para dejar oír la pequeña voz del mundo. La voz es a menudo correcta, es inteligente, es interesante, pero no es la voz del poema, se ha quedado en los estadios de su formación, se ha desatado del fondo que le da su ser y ya no fluye por el río que a ambos alimenta. Se ha cortado, entonces, la marea y la lengua es lengua muerta, no importa cuan famosa sea la patética figura.

Sí, yo es otra. Yo es en otras. No en mi voluntad de enunciación. Pero quizás sí en la crianza de mi alma. Si el estilo es el espíritu individual, éste es simplemente quien lleva a cabo el recorte, quien rastrilla en el océano del gran rumor donde el vulgo canta.

Y la epifanía de este canto es a veces sentido y a veces herida del sentido. Si la orfebre engarza bien las chispas de la hoguera, cardúmenes luminosos que saltan siendo, volviendo a ser materia opaca, entonces

el objeto que compone, el poema, es una cicatriz que ante los ojos de quien lee, ante la escucha, vuelve a abrirse en herida resplandeciente, vuelve a ser de quien fue siempre: el vulgo. Por un instante parpadea y da cuenta, da memoria del rumor. Se refleja en el cristal de agua de quien posee también la voz pequeña. Nuestra tarea no es ir lejos, es ir cerca. Construir espejismos que nos ayuden a vernos en el espejo.

El lirismo más puro es siempre arcaico. Señala una sola cosa: nuestra pertenencia. A la casa de lo humano, a la casa de la materia por supuesto, y al pequeño pago de la lengua. Gloria y fragilidad de su sentido puesto en duda, afirmado, puesto en duda..., en medio del gran coro, por la idiota de la familia, es decir, la voz de la poesía.

...

5

La pregunta, o la afirmación en torno a cuánto se lee poesía, o a lo poco que se la lee, es de vieja data. Los argumentos también. Sin duda es una lectura de resistencia, una lectura exigente que demanda atención, en su brevedad y gesto preciso reclama creación de parte de quien lee, se completa en la actividad profunda y secreta del lector. ¿Pero no es así toda literatura, el arte entero? La complacencia de iluminados con que ciertos poetas justifican que la poesía pueda leerse menos me parece una falsía. Sí, entre sus tareas se halla sin duda la de desestabilizar la lengua, dudar de su materia o de su ordenamiento. ¿No hace eso el arte entero? Quienquiera que haya participado de un acto de creación popular, como las murgas carnavaleras por ejemplo, sabe que si se entrega ya no será el mismo, ha pasado por experiencias exigentes y conmovedoras que cambiaron su cabeza y su corazón. No hay otra forma de leer, ni de compartir los instantes extraordinarios a lo largo de la nada ordinaria vida.

Sin embargo, oigo un murmullo insistente y nuevo: la preocupación por el mercado. Se vende o no, el panteón de los medios de comunicación otorga o no otorga un lugar de cierta publicidad asegurada. Insistente el murmullo y acorde con los tiempos. No señores, no se vende casi nada, salvo rarísimas excepciones el arte no se vende en la contemporaneidad de su producción. Y es ese secreto íntimo por donde circula mientras guarda el anhelo de encontrarse con el corazón del mundo entero, lo que resguarda a la pequeña voz. Le otorga autonomía, comarca, regionalidad en medio de la peligrosa globalidad con la que se intenta manipular las diferencias y el riesgo que implica toda exploración, todo ejercicio del libre albedrío, los aciertos y desaciertos de la conciencia. Nunca es la poesía expresión de la colectividad, ni siquiera tribal, menos del estado y su constante voracidad imperial, o de los emporios del dinero tan poco interesados en aquel encuentro cuerpo a cuerpo, comunión con el lector, y sí en la plusvalía del dinero y el poder. El actual murmullo insistente de la pregunta—se vende o no se vende—me parece en buena parte generado por el propio mercado. Entre tanto hay audiencias cada vez mayores en los recitales de poesía, ¿será por el poeta poniendo el cuerpo?, ¿por la otra lógica de la poesía, su asalto a la razón?, ¿por su condición de prima hermana del habla que persiste más allá de todo lo dicho en torno a que la poesía contemporánea fue escrita para ser leída con el ojo, no para escucharla? ¿Qué observa

ahora el mercado allí? No veo planes editoriales que incluyan colecciones de poetas contemporáneos, de poetas argentinos de varias generaciones enmudecidas y hechas desaparecer, de poetas mujeres que han sostenido con vitalidad la resistencia en las últimas décadas, desde los setenta hasta nuestros días. Lo que veo es la señal de tránsito apuntada al espectáculo. Salvo en las editoriales independientes, en las pobres, en las cooperativas de escritores que se las arreglan no sólo para sobrevivir sino que se multiplican como hongos en la humedad, se apropian de los medios de producción, o sea las migajas de la tecnología contemporánea, de los intersticios donde se genera un minúsculo "mercado" maloliente de resistencia y gozan de buena salud, *tienen* lectores. Sigo pensando que la poesía es la expresión de la desnuda intemperie de un sujeto hablándole a otro, tan cerca y tan lejos. Su potente fragilidad puede volverla un bocadito codiciado. Preocupados por la gota de autoría personal olvidamos el torrente. Claro que la escena fáustica nos acecha, como a cualquier ser humano— ¿quién no quiere prestigio y fama, ser atendido, ser respetado y por sobre todo amado en algún rincón del alma? —, pero también es condición de la época que hayan convertido a los artistas en espectáculo o en desecho. Así, quedamos afuera del aparato productivo como millones de personas sin empleo, nos conciben basura y podemos aprender de los maestros, como ellos ser cartoneros y piqueteros en el cruce de las carreteras. Si lo olvidamos ellos nos lo recuerdan, cada una de las caras ennegrecidas y sudorosas con la dignidad de quien resiste y dice: no lograrán que deje de ser un ser humano.

Perdidos en la noria monótona de un trabajo alienado o en el terror de la ausencia de trabajo. ¿Lo recordamos? Sí. Aún así meditamos sobre el amor, sobre la vida y la muerte, y es nuestro error suponer que sólo el ocio confortable lo provoca. Que es nuestra propiedad aquel sutil abanico de pensamientos y emociones. Error que nos aparta del lector más que el mercado. La poesía es de la gente, de cada uno, y nuestra tarea es la atención y el oficio, como cualquier trabajo bien hecho. Y en la atención y el oficio estoy a solas, construyo mi espíritu, pero nada podría hacer sin la presencia de los otros que me permiten ser un ser humano. Siempre están, aún por ausencia. Sin embargo, un autoritarismo antropocéntrico que viera en toda representación donde no se imprime en primer plano la cuestión humana como un ornato, es una visión iluminista de occidente, la modernidad que habiendo catalogado todo lo que pudo de lo viviente intentando convertirlo sólo en museo, incluyó también a la gente y puso un sello: he aquí lo que existe, inmóvil, y si es posible muerto. Naturaleza muerta. Olvida que la cuestión humana está en la mirada, íntima, individual y siempre nueva que se alza desde los acordes de la base y desde el imaginario de un presente nada esencial sino recortado en términos de expectativas de vida o acceso a bienes simbólicos. Para nosotros, americanos, a quienes nuestro pasado y nuestras condiciones materiales y sociales no nos dejan ser occidente, recordarlo no nos resulta tan difícil. Habla el enjambre vivo de un edificio en las ciudades, las ruinas portuarias, las fábricas en ruinas, los supermercados, las avenidas y el humo sobre el río, las hojitas del sauce que giran y caen, el benteveo, la balsa cargada de álamos deslizándose en el agua y la silueta del peón que toma mate y alza su mano saludándonos. Habla. *Dios está vivo/ la magia viene caminando.*

The Little Voice of the World

Diana Bellessi

[Fragments]

I

THAT LITTLE VOICE OF the dream or of the vigil more attentive than the idiot of the family who listens, her eyes fixed on the glory of forms. She tries to translate it with the same innocent tools of the common people. But sometimes the idiot chokes up the little voice, it engulfs her, and does not let the graceful melody flow where it will. That little voice that writes the poems. Who, if not her, could say no one swims in the same river twice. Subtle archaism of a thought that does not wish to go much beyond the offering or the celebration of minute revelations, always repeated, time and again upon the imprint of human consciousness. Pure emotion that is translated, that is cooled off as an inevitable condition of the trimming; and which blazes again, if one is fortunate, thanks to the resurrection of sound on the haunches of which meanings and significations are woven like a harness that allows one to mount a brilliant little horse.

The voice of the poem, the voice that the poet believes to be hers. Her avant-garde condition consists in bring up the rear, a lookout from the depths, a fire-eater merging with the last anonymous silhouette of the entourage of the fair. She holds the poet up, from afar, from behind, driving her to become the crest. Background and figure moving fleeting to the beat of the heart.

The tasks of this voice: to remain attentive to that which is useless, discarded, because there, smallest detail, rises for her what she feels epiphany. The tasks of this voice: to undo the discursive crystallizations of the "useful" and to weave a fine sieve able to catch the slivers of that which is revealed. Attention and artisanship. The tasks of this voice: to untie oneself from what one has *learned* that must be previously learned, to thus diminish the echoes of the high voices to be able to hear the little voice of the world. The voice is often correct, it is intelligent, it is interesting, but it is not the voice of the poem, it has remained in the stages of its formation, it has untied itself from the background that gives it its being and no longer flows in the river that feeds both. The tide has thus been severed; and the tongue is a dead tongue, regardless of how famous the pathetic figure may be.

Yes, I am an other. I am in others. Not in my will to enunciate. But perhaps in the nurturing of my soul. If style is individual spirit, then it is simply the one who undertakes the trimming, the one who rakes the ocean of the great murmuring where the common people sing.

And the epiphany of this song sometimes is meaning and sometimes is the wounding of meaning.

If the goldsmith sets the sparks from the bonfire well, luminous shoals jumping, becoming once again opaque matter, then the object that she composes, the poem, is a scar that, before the eyes of the one who reads it, listens to it, opens again into a radiant wound, returns it to whom it always belongs: the common people. For an instant it blinks and recounts, gives memory to the murmuring. Reflects in the water crystal of the one who also possesses the little voice. Our task is not to go far, it is to go near. To construct illusions which allow us to see ourselves in the mirror.

The purest lyricism is always archaic. It indicates only one thing: our belonging. To the house of what is human, to the house of matter, of course, and to the little village of the tongue. Glory and fragility of its meaning placed in doubt, affirmed, placed in doubt—in the middle of the great chorus, by the idiot of the family, which is to say, by the voice of poetry.

...

5

The question, or the affirmation with respect to how much poetry is read, or to how little it is read, is an old one. The arguments as well. Without a doubt it is a reading of resistance, an exacting reading that demands attention, its brevity and precise gesture calling for creation from the one reading, it is completed in the profound and secret activity of the reader. But is not all literature, the entirety of art, like this? The complacency of enlightened ones with which some poets justify that poetry is less read seems to me to be a false one. Yes, among its tasks, without a doubt, is that of destabilizing language, of questioning its materiality or its ordering. Does the entirety of art not do this? Anyone who has participated in an act of popular creation, such as the *murgas*, the carnival street bands, for example, knows that if you surrender yourself you are no longer the same, that you have lived through demanding and moving experiences that have changed your head and your heart. There is no other way to read, nor of sharing the extraordinary moments of our not-at-all ordinary lives.

But I hear a new, insistent murmuring: the concern about the market. Does it or does it not sell, does the pantheon of the means of communication grant it or does it not grant it a certain amount of guaranteed publicity. An insistent murmuring, in accordance with the times. No sirs, it does not sell almost at all, except in the rarest of cases art does not sell contemporaneously with its production. And that intimate secret through which it circulates while it protects the yearning to reach the heart of the entire world, is what shelters the little voice. Grants it autonomy, territory, regionality in the middle of the dangerous globality that attempts to manipulate differences and the risk involved in all exploration, all exercise of free will, the hits and misses of conscience. Poetry is never the expression of a collectivity, not even of a tribal one, even less of the state and its constant imperial voracity or of the emporiums of money, so uninterested in that body-to-body encounter, which is to say, the communion with the reader. The current insistent murmuring of the question—does it sell or does it not sell—seems to me generated in large part by the market itself. Meanwhile, all the time larger and larger audiences appear at poetry

recitals, perhaps because the poet puts his body there? Because of the other logic of poetry, its attack on reason? Because of its condition as first cousin to speaking that persists beyond everything that is said regarding contemporary poetry being written to be read by the eye and not to be heard? What does the market observe there now? I do not see any editorial plans that include collections of contemporary poets, of Argentine poets from various generations who have been muted and made to disappear, of women poets who have kept up the resistance with vitality in the last few decades, from the sixties to our days. What I see is the traffic light aimed toward the spectacle. Except for the independent presses, the poor ones, the writers' cooperatives which find a way not only to survive but also to multiply like fungi in the humidity, to appropriate the means of production, which is to say the crumbs of contemporary technology, the gaps where a miniscule, foul-smelling "market" of resistance is generated, for they enjoy good health, *they have* readers. I still think poetry is the expression of the naked inclemency of one subject speaking to another, so close and so far. Its potent fragility can turn it into a coveted little bite. Worried about the drop of personal authorship we forget the avalanche. Of course the Faustian scene lurks for us, like any human being—who does not want, in some corner of their soul, prestige and fame, to be looked after, to be respected and above all, to be loved?—but it is also a condition of our time that artists have been converted into spectacles or remainders. Thus, we are left outside the apparatus of production like millions of people without work, we are conceived of as trash; and we can learn from the teachers, like them we can be *cartoneros* (cardboard gatherers) and *piqueteros* (picketers) at the crossroads. If we forget, they shall remind us, each of their faces, blackened and sweaty, with the dignity of one who resists and says: in spite of them, I am still a human being.

Lost in the monotonous treadmill of alienating work or in the horror of the absence of work. Do we remember? Yes. Even so we meditate on love, on life and death, and we are mistaken if we suppose that only comfortable idleness can incite it; that our property is such manner of subtle waves of thoughts and emotions. A mistake that distances us more from the reader than from the market. Poetry belongs to the people, to each individual; our task is attention and craft, like any other job well done. And in the attention and the craft I am alone, I build my spirit, but I would not be able to do anything without the presence of the others who allow me to be a human being. They are always present, even through absence. But an anthropocentric authoritarianism that would see, in every representation where it is not imprinted, the human question like an ornament, in the foreground, is an Illuminizing Occidental viewpoint, modernity which having catalogued everything that it could from the living trying to convert it solely into a museum, also included people and put a stamp on it: here is what exists, motionless, and if possible dead. A still life. It forgets that the human question is in the intimate and individual gaze, which always rises from the chords of the base and from the imaginary of a present that is not-at-all essential but is trimmed, rather, in terms of expectations of life or access to symbolic goods. For us, as Latin Americans, for whom our past and our material and social conditions do not allow us to be Occident, recalling it does not turn out to be

that difficult. The live swarm of a building in the cities speaks, in the portside ruins, the factories in ruins, the supermarkets, the avenues and the smoke over the river, the little leaves of the willow that spin and fall, the *benteveo* bird, the raft loaded with poplars gliding on the water and the silhouette of the laborer drinking *mate* and raising his hand to greet us. It speaks. *God is alive / magic is afoot.*

Translated by Sergio Waisman

II. Poetry

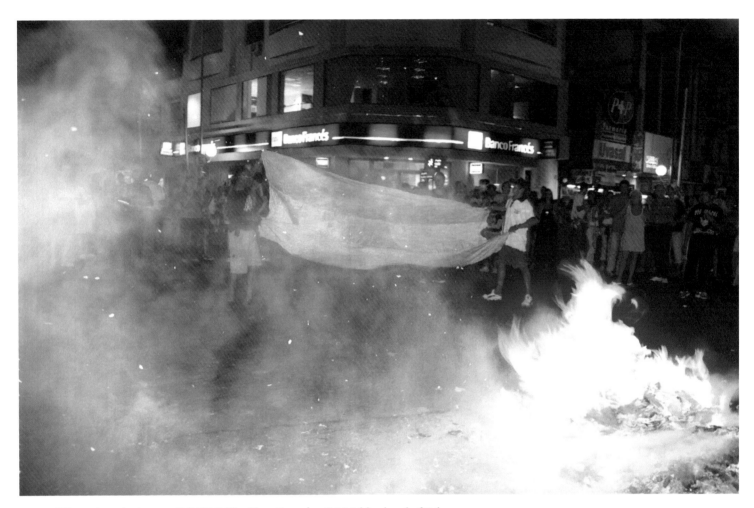

1. "Cacerolazo de clase media" / "Middle Class *Cacerolazo*." Neighborhood of Belgrano.

amanece	day breaks
niebla de ceniza	ashen mist
sobre tierra de ceniza	on ashen earth
mujeres	women
espectros de ceniza	specters of ash
entre ráfagas de ceniza	among gusts of ash
se unen	come together
con la lentitud de la ceniza	with the slowness of ash
y	and
amorosamente	lovingly
toman puñados de ceniza	take fists of ash
y amasan	and knead
con cánticos antiguos	with ancient songs
la que será	what will become
una Patria nueva	a new Motherland
habrá que amamantarla.	it will have to be nursed.

Barbara Gill *Translated by Sergio Waisman*

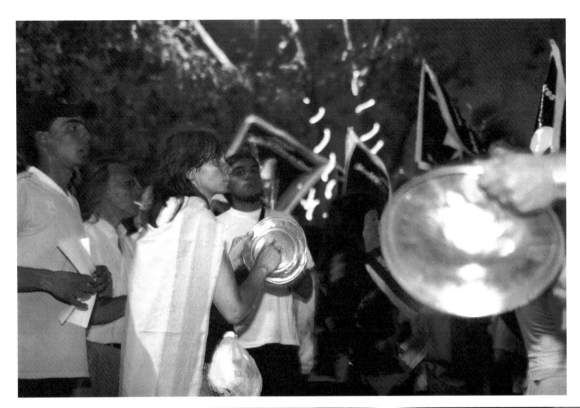

2. "Cacerolazo en Plaza de Mayo" /
"*Cacerolazo* at the Plaza de Mayo."

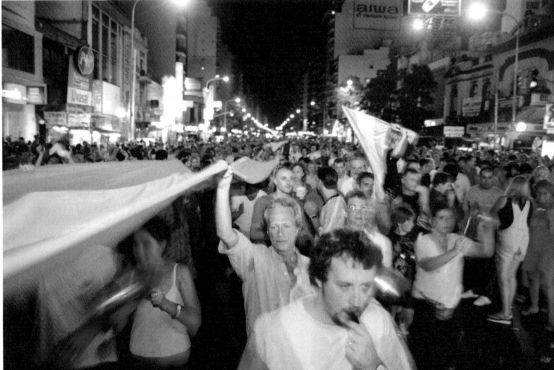

3. "Banderazo y cacerolazo" /
"*Banderazo* and *Cacerolazo*."
Neighborhood of Belgrano.

Anclada en el Riachuelo
con un trapo podrido por bandera
huelo el amarillo de las barcas oxidadas.

Estancada.

¿Hay un arroyo profundo corriendo limpio al infinito?

Hipérbole constante esta patria:
bandera idolatrada
grito sagrado
honra sin par
noble igualdad.

Febo ilumina los históricos
 ladrones
 corruptos
 asesinos
 cobardes.

Yo soy cobarde, me quedé atada al mástil.
Y sé por qué.

Betty Tosso

Anchored in the Riachuelo[1]
with a rotten rag as a flag
I smell the yellow of the rusted boats.

Stagnating.

Is there a deep clean stream flowing to infinity?

A constant hyperbole, this motherland:
idolized flag
sacred scream
unmatched honor
noble equality.

Phoebus illuminates the historic
 thieves
 the corrupt
 murderers
 cowards.

I am a coward, I stayed tied to the mast.
And I know why.

Translated by Sergio Waisman

1 The "Riachuelo" River (literally "little river") originates in the Buenos Aires Province, defines the southern border of the Buenos Aires federal district, and flows into the River Plate. The mouth of the river (la "Boca") gives the name to the famous neighborhood (and soccer team) la Boca. The "Riachuelo" is quite polluted from the industrial waste of the numerous factories along its length. (Translator's Note)

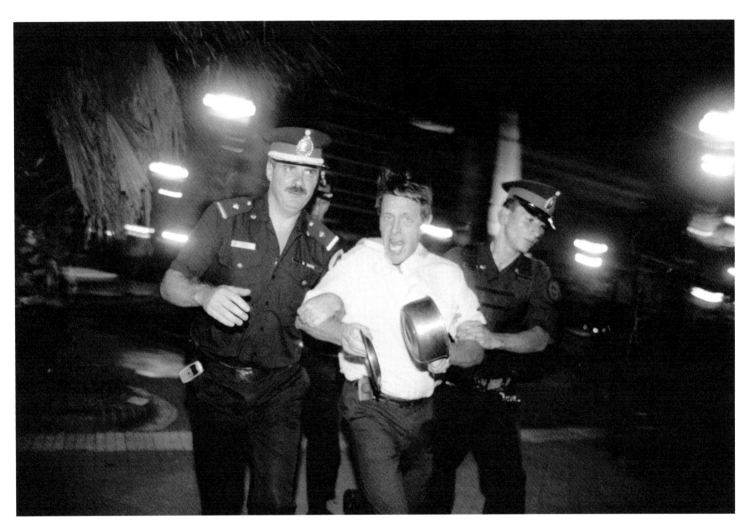

4. "Tolerancia cero" / "Zero Tolerance."
 The Federal Police taking away a detained demonstrator from the Plaza de Mayo, the night of the *cacerolazo* in December, 2001.

Buenos Aires, Temperley
agosto 2002

este día tardecino de agosto
lagrimea sangre
manos abiertas
labios ateridos
crujientes calles
de desechos.

Marta Cwielong

Buenos Aires, Temperley[1]
August 2002

this twilighting August day
sheds tears of blood
hands outstretched
lips numb
streets crumbling
with remains.

Translated by Sergio Waisman

1 Temperley: A district (now primarily a suburb) south of the city of Buenos Aires. (Translator's Note)

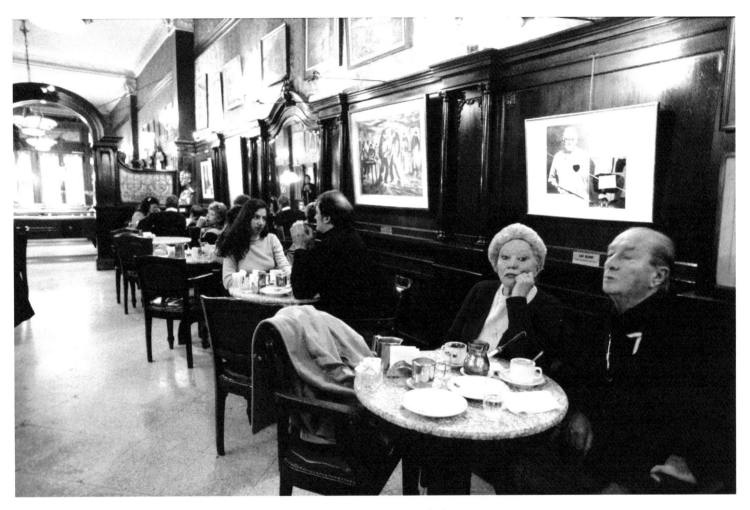

5. "Café Tortoni, tarde de domingo" / "Café Tortoni, Sunday Afternoon." Avenida de Mayo.

Es hora. Nadie dice palabra.
El vino y en los vasos, vinagre.
Flota el dolor en medio de las caras.

Afuera, pegotea caminos, la oscuridad.
Tres veces afilada, sin vino y sin pan,
la mesa siega ojos y voces.

Miradas que desatan
hambre y sed.
hambre y sed de...

Tal vez, alguien se anime.
Alguien que diga una oración,
hable de amor, consuele.
Que se conduela,
Alguien
y nos mejore este nivel
 de muerte.

Olga Drennen

It is time. No one says anything.
The wine; and in the glasses, vinegar.
Sorrow hovers on everyone's face.

Outside, paths thicken, darkness.
Three times sharpened, without wine,
 without bread,
the table blinds eyes and voices.

Eyes that unleash
hunger and thirst.
hunger and thirst for...

Perhaps, someone will dare.
Someone who'll say a prayer,
speak of love, comfort.
Will someone
take pity
and improve this state
 of death.

Translated by Sergio Waisman

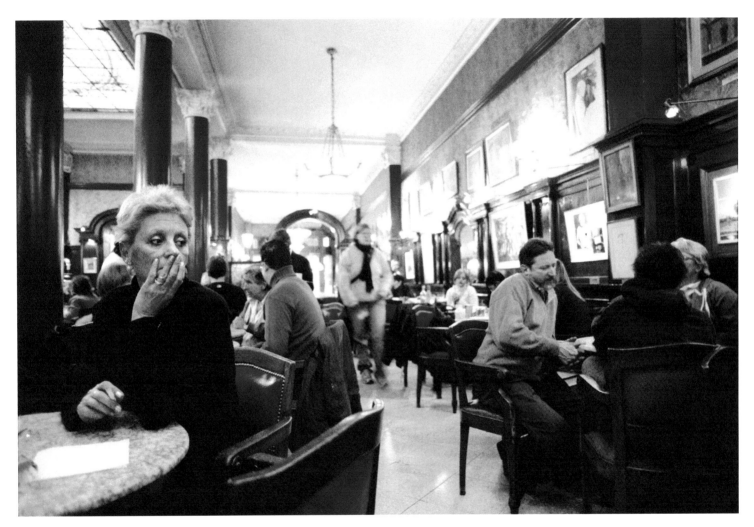

6. "Café Tortoni, tarde de nostalgia" / "Café Tortoni, Nostalgic Afternoon." Avenida de Mayo.

Cuando era niña
Argentina
fue el General San Martín
jinete en unicornio blanco
galopando heroico
por las páginas de *Billiken*.

Después
Argentina me supo al vino triste
y la palabra sabia
de amigos nuevos
que burlaron la guerra sucia
y nos trajeron
un mar de ausentes
reventando en las pupilas.

Hoy
Argentina me sangra
y se me quiebra
y lloro tanto,
como si San José
limitara al norte con Buenos Aires
y al sur con Tierra del Fuego.

Sabés,
con el corralito
se fue
también
mi infancia.

Marjorie Ross

When I was a girl
Argentina
was General San Martín[1]
galloping heroically
through the pages of *Billiken*[2]
on a white unicorn.

Then
Argentina became sad wine
and the wise word
of new friends
mocking the Dirty War
bringing us
a sea of absent people
bursting in their pupils.

Today
Argentina bleeds
and breaks on me
and I cry so much,
as if San José
bordered Buenos Aires to the north
and Tierra del Fuego to the South.

You know,
with the *corralito*[3]
my childhood
left me
too.

Translated by Sergio Waisman

1 General José de San Martín (1778–1850): The most important hero and principal leader of Argentina's successful struggle for independence from Spain. (Translator's Note)

2 *Billiken*: A weekly children's magazine in Argentina, founded in 1919 by Constancio Vigil. (Translator's Note)

3 *Corralito*: From the diminutive for "corral" (which means animal pen or enclosure, as well as playpen), *corralito* was the informal name for the economic measures taken in Argentina toward the end of 2001 in an attempt to stop the run on the banks at the time of the economic crisis that year. The *corralito* froze most bank accounts and forbade nearly all withdrawals from US-dollar connected accounts in Argentina. (Translator's Note)

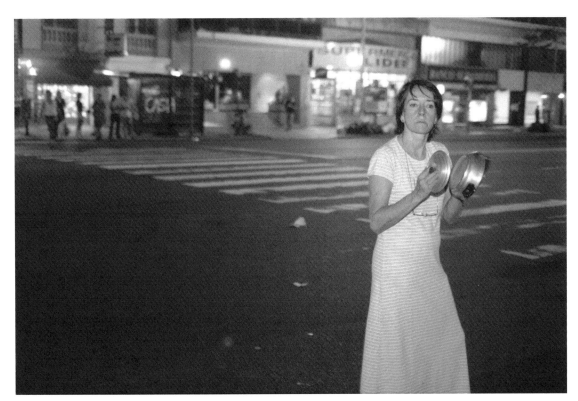

7. "Cacerolazo popular" /
 "Popular *Cacerolazo.*"
 Avenida de Cabildo,
 Neighborhood of Belgrano.

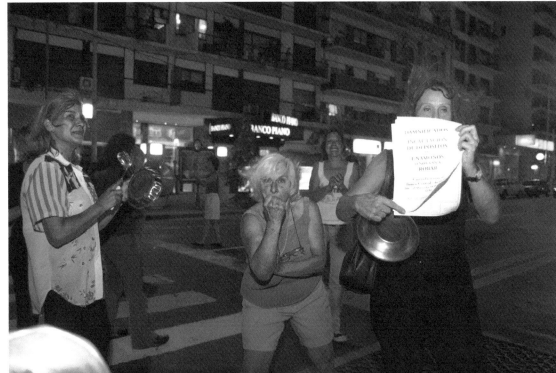

8. "Indignación, impotencia..." /
 "Indignation, Impotence... "
 Avenida de Cabildo,
 Neighborhood of Belgrano.

Los cacerolazos

La cacerola, descendiente directa de la vasija aborigen y el caldero de la brujas, apareció en la escena nacional como instrumento de cambio y transformación.

En este sentido, los cacerolazos con un alto porcentaje de protagonismo femenino son rituales colectivos donde las mujeres estamos cerca de la chamán aborigen, la bruja desafiante y la sacerdotisa del cáliz sagrado. Si el caldero y la vasija surgieron del ámbito arquetípico femenino con esta función transformadora, es posible que ahora retornemos a la cocina y a las cacerolas con una visión más integral entre lo que se cocina en el hogar y lo que se cocina en la sociedad.

Analía Bernardo

The *Cacerolazos*[1]

The pot—a direct descendent of the aboriginal receptacle and the witch's cauldron—appeared on the national scene like an instrument of change and transformation.

In this sense, the *cacerolazos*—with their high percentage of female protagonists—are collective rituals in which we women are near the aboriginal shaman, the defiant witch and the priestess of the sacred chalice. If the cauldron and the receptacle arose from archetypical feminine settings with this transformative function, it is possible that we are now returning to the kitchen and its pots with a more integral vision between what is cooked up at home and what is cooked up in society.

Translated by Sergio Waisman

1 *Cacerolazo*: A neologism, the *cacerolazo* comes from the Spanish word *cacerola*, which is a common pot. The street protests of 2001 to which this poem refers consisted of coming out to the streets and banging pots and pans to make as much noise as possible, and were hence referred to as *cacerolazos*. (Translator's Note)

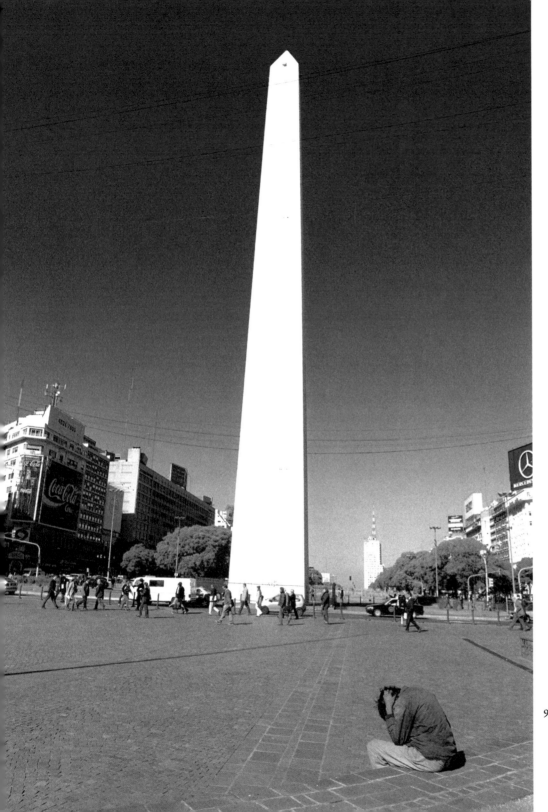

9. "Ciudad imponente e impotente" /
 "Imposing, Impotent City."
 Avenida 9 de Julio and
 Avenida Corrientes.

Crisis in Buenos Aires:

El oficio de la pérdida

Respiro la pena,
sentada
sobre el plato vacío
a la orilla de la historia.

...

Me rasuro las pestañas
y enjuago
mi ojo herido
por esta crónica
de servidumbres sublevadas.

Valeria Flores

The Task of Losing

I breathe in the sorrow,
sitting
before the empty plate
at the edge of history.

...

I pluck out my eyelashes
and wash
my eye wounded
by this chronicle
of revolted servants.

Translated by Sergio Waisman

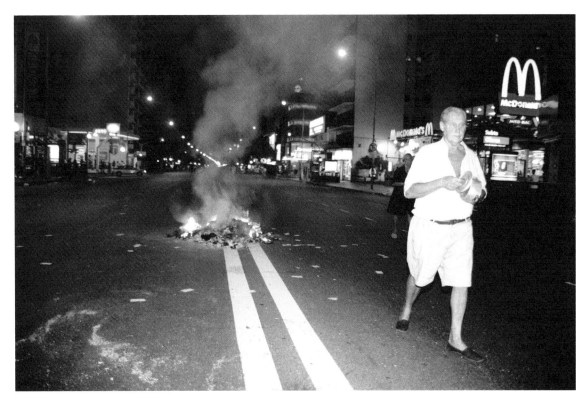

10. "Desolación" /
"Desolation."
Avenida de Cabildo,
Neighborhood of Belgrano.

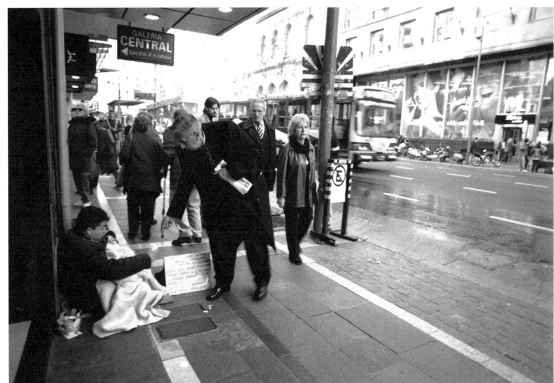

11. "Solo una ayuda me salvará" /
"Only a Little Help Will Save Me."
Right in the middle of
Avenida Corrientes.

Salmo por la ciudad de Buenos Aires	**Psalm for the City of Buenos Aires**

<table>
<tr><td>

Esta ciudad se ha llenado de mendigos en las calles
De fotos de ladrones en los diarios
De muchachos que buscan un lugar donde no se los desprecie.
Esta ciudad se ha vuelto irrespirable
Se ha llenado de miedo y de tristeza
De gente baleada en la vereda
De soberbios e imbéciles que ríen entre las nalgas de mujeres
De viejos que duermen en la plaza entre cartones.
Esta ciudad no trepa ya a sus azoteas y expulsa con aceite y
 excremento al que la invade
Esta ciudad aplaude al enemigo
Corona a sus piratas
Esta ciudad saqueada, abandonada
Esta ciudad golpeada, acribillada
Violada, traicionada, delirada
Esta ciudad abandonada, suicidada
Pide que le limpien los gusanos, las moscas, las serpientes
Pide que le devuelvan su delantal de madre,
 su diadema de abuela,
Su caminar de reina.
Pide que otra vez brille en su cielo sobre el río
El alto hermoso incendio de la indignación.

</td><td>

This city has become filled with beggars in the streets
With pictures of thieves in the newspapers
With youngsters searching for a place where they will
 not be despised.
This city has become unbreathable
It has become filled with fear and sadness
With people shot on the sidewalks
With haughty fools laughing between women's buttocks
With old men sleeping on cardboard in the plaza.
This city no longer climbs up to its terraced roofs to expel
 with oil and excrement those who invade her
This city applauds its enemy
Crowns its pirates
This city, pillaged, abandoned
This city, beaten, bombarded
Violated, betrayed, delirious
This city, abandoned, suicided
Asks that her worms, her flies, her serpents be cleaned from her
Asks that the mother's apron, the grandmother's diadem,
 the queenly walk,
Be returned to her.
Asks that the beautiful fire of indignation
Glow once again in the sky over her river.

</td></tr>
</table>

Ivonne Bordelois

Translated by Sergio Waisman

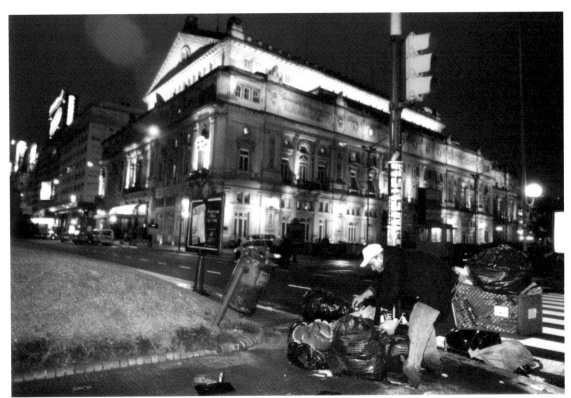

12. "Contrastes en el
 Teatro Colón" /
 "Contrasts at the
 Teatro Colón."

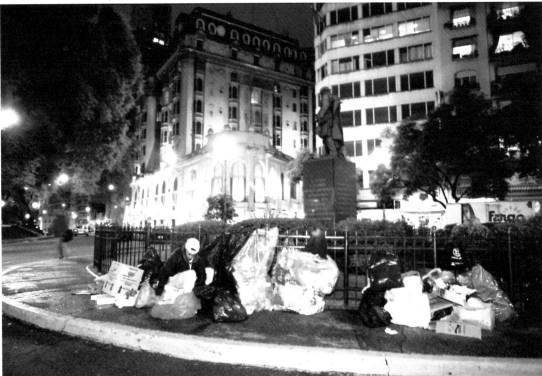

13. "Mi casa" / "My House."
 Plaza San Martín.

X

Plagado
Plegado
Pegado
Cartones
Desplegados
Plagiados
Esa plaga
Ese pliegue
Ese despliegue
Del dolor
Co-ti-dia-no
Algo
De la asfixia
De lo insostenible
De la línea
De la historia
cuando retrocede.

Zulema Moret

X

Plagued
Pleated
Patched
Cardboard
Deployed
Plagiarized
That plague
That pleat
That deployment
Of ev-er-y-day
Pain
Something
About asphyxia
About the unsustainable
About the line
About history
when it recedes.

Translated by Sergio Waisman

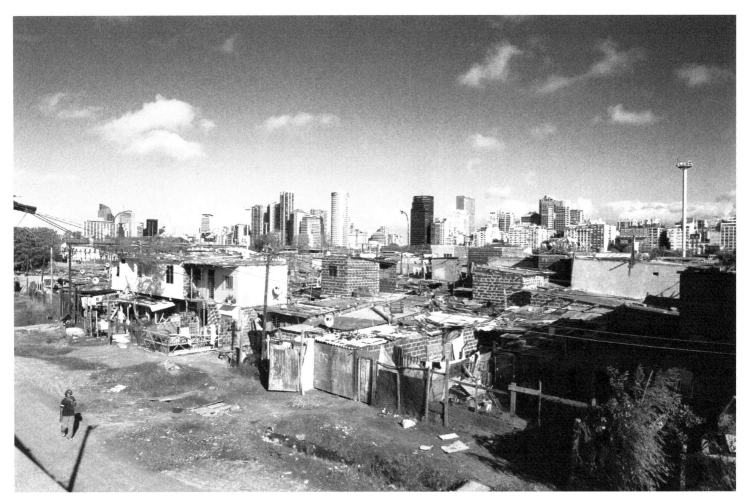

14. "Contrastes" / "Contrasts."
 View of the Villa de Emergencia de Retiro from the 25 de Mayo Expressway.

Últimas fotos del naufragio

3-

A la salida de las muertes presentidas
Marcadas, señaladas
Las hileras de cartoneros
Construían una nueva ciudad
El miedo apretaba los corazones peatonales
Y llorábamos la disolución de algo siempre habitado

Preferí entonces apretar en los bolsillos tristes
Las pérdidas personales
Gorriones al acecho de una ventana
Desde donde volar al mundo.

(Fragmento)
de *Poemas del Desastre*

Zulema Moret

Last Pictures of the Shipwreck

3-

At the exit of deaths foretold
Branded, marked
The rows of cardboard collectors
Were building a new city
Fear was gripping the hearts of the pedestrians
We cried the dissolution of something
 always inhabited

I preferred then to grip in the sad pockets
Personal losses
Sparrows looking for a window
From which to fly off into the world.

(Fragment)
from *Poemas del Desastre*

Translated by Sergio Waisman

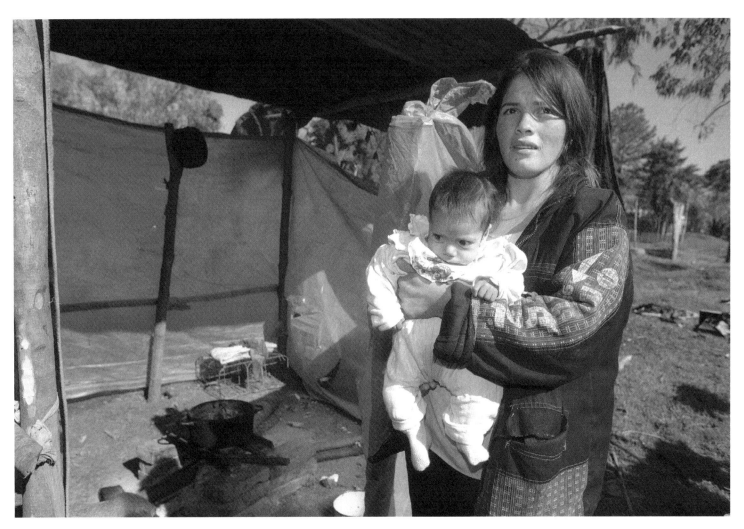

15. "Madre del dolor" / "Mother of Sorrow."
 Beatriz Orresta with her son Santiago, who died of malnutrition several months after the photo was taken. Tucumán Province.

Muerte por hambre

Son las ocho y reflejan los celajes
el espejo en sangre que el agua enturbia

Con rojo de banderas de plumajes
de las hojas de capullos y de flores

del sol que muere para este día y de la noche
en ciernes de lo que nace de lo que hiede

enjuto rojo con gusto a poco de lo que falta
de los porotos de las lentejas y los tomates

de la bendita carne asada de los otros
de las encías lengua dientes y labios rojos

de la comida que no ha sido vista ni dada
a la pancita hinchada a los brazos del grosor

de un dedo a las patitas que no sostienen
y a la mirada tenue de quien se va se muere

no de viejo no de enfermo no de guerra
ni de calor ni frío ni de accidente

ni dios siquiera de hambre sólo de hambre
puerca persiguiendo como un águila

Death by Hunger

It is eight o'clock and the mirror reflects
on blood the streaks that the water muddles

With red of flags of plumage
of the leaves of cocoons and of flowers

of the sun that dies for today and of the night
budding from what is born from what reeks

meager red with a bit of what is missing
of the beans of the lentils and the tomatoes

of the blessed grilled beef from the others
of gums tongue teeth and red lips

of the food that has not been seen nor given
to the swollen little belly to the arms of the thickness

of a finger of the little legs that do not hold up
and to the tenuous gaze of the one who's leaving dying

not of old age not of illness not of war
not of heat nor cold nor from an accident

nor by god just of hunger only of porcine
hunger hunting like an eagle

>>> >>>

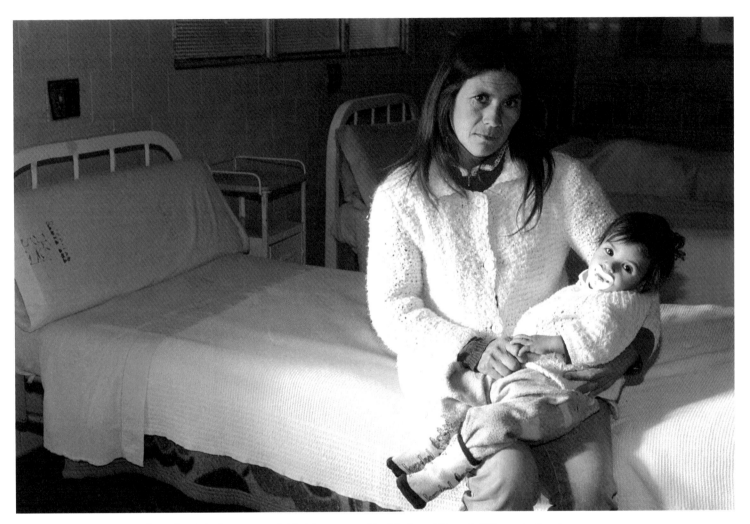

16. "La desnutrición: la madre de la desesperanza" / "Malnutrition: The Mother of Despair." Tucumán Province.

a los pichones de torcaz y no se grazna
no se grita lo bastante no se baten

las alas y las plumas y los picos
aunque no se vaya y no se espante

el rapaz maldito que quiere más
el rumor del hambre el desmayo ausencia

de cualquier rumor en la atonía del hambre
de falta de agua de parásitos de comer

tierra por hambre por comer lo que sea
se tantea gordura propia tersura

de la indiferencia de ochocientos millones
sufren hambre en el mundo, sesenta

millones de chicos mueren veinticinco
mil gentes por día de un hambre necia

y roja como las aguas de este río
que recuerdan la sangre faltante y

derramada cuando la noche enturbia
el rojo atardecer y magos y dioses

y madres bien alimentadas el cielo
nos guarde la tierra nos perdone y are

con surcos hondos el alma en peligro
en medio de la obscena abundancia.

Diana Bellessi

the young of a wood pigeon but not enough
squawking or screaming or enough beating

of the wings and the feathers and the beaks
even if it does not leave and it does not frighten away

the rapacious wrong that wants more
the rumbling of hunger the fainting absence

of any rumbling in the atrophy of hunger
of lack of water of parasites of eating

dirt out of hunger out of eating whatever
feeling ones own round smoothness

of the indifference eight hundred million
suffer hunger in the world, sixty

million children die twenty-five
thousand people per day of a hunger foolish and

red like the waters of this river which
remind us of the blood missing and

spilt when night muddles
the red afternoon and wizards and gods

and well-fed mothers may the heavens
keep us the earth forgive us and plow

with deep furrows the soul in danger
amid the obscene abundance.

Translated by Sergio Waisman

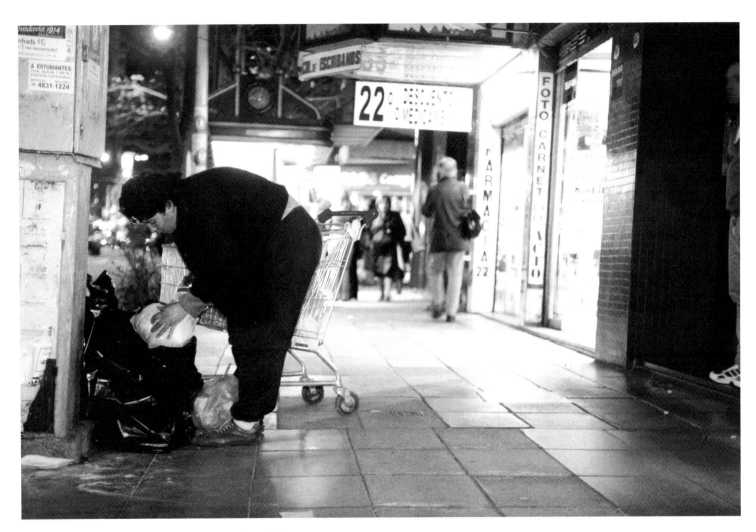

17. "El oro de los pobres" / "Poor-Person's Gold."
 An indigent woman looks for food right in the middle of Avenida Santa Fé,
 a well-known residential area of the Buenos Aires middle class.

Regina/ Reina

El hilo de seda negro de la noche sobre tu cuerpo
que se defiende del viento con un paraguas roto
todo lo que hallamos en la basura sirve, para
leer el revés del paraíso, la página oculta del
paisaje humano, ese turismo prohibido,
el cartón de leche con niños secuestrados
el papel de manteca con los dedos secos y
rosas pegados a las letras de "pasteurizado",
una cáscara brillante de galletas para adelgazar
o para no tener calorías demás, la síntesis
del reino semiótico, el resto de lechuga que
vuela como un pájaro espantado.

Ella revuelve y sabe que se incrusta en el
terreno familiar de la orgía de una cena
que no será posible: sola/ con los otros.

Y al derramar el corazón sobre una bolsa
brillante se proclama reina, madre, señora
de esta visión del infierno, sin mantos radiantes
y sin rostro joven, y sin el halo de aquellas
matronas del renacimiento.

Gladys Ilarregui

Regina / Queen

The black silk string of night on your body
defending itself from the wind with a broken umbrella
everything we find in the trash is useful, to
read the reverse of paradise, the hidden page of the
human landscape, that forbidden tourism,
the milk carton with kidnapped children
the butter wrapping paper with dry pink
fingers stuck to the letters "pasteurized,"
a bright shell of crackers to lose weight
or to avoid extra calories, the synthesis
of the semiotic kingdom, the left-over lettuce
flying like a startled bird.

She pokes about, knowing she is inlaying herself in the
familiar terrain of the orgy of a dinner
that will not be possible: alone / with the others.

As she pours out her heart on a bright
bag she proclaims herself queen, mother, lady
of this vision of hell, without beaming mantles
and without a young face, and without the halo of those
matrons of rebirth.

Translated by Sergio Waisman

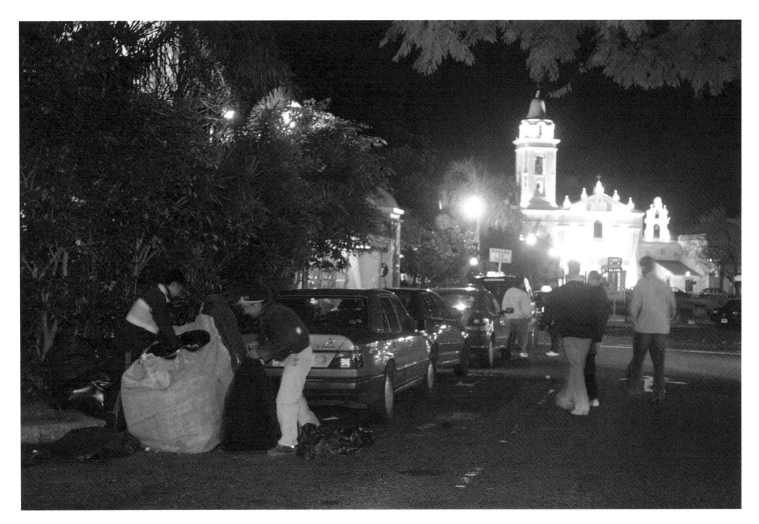

18. "El oro de los pobres II" / "Poor-Person's Gold II."
 A group of men look for food in the neighborhood of Recoleta, a residential and main
 strolling area of the Buenos Aires middle and upper classes.

Crisis in Buenos Aires:

Buenos Aires: historia del anochecer

Esta noche:
hundidos en el fondo de una bolsa de residuos
resplandecientes trozos de luna, polvo de plata
entre las cajas de aluminio, en los estuches vacíos
océanos de noche incontenible y profunda
bajan a la ciudad paris, con manos lastimadas.

>>>

Buenos Aires: Story of Nightfall

Tonight:
submerged at the bottom of a bag of refuse
radiant scraps of moon, silver dust
among aluminum boxes, in the empty cases
oceans of night deep and uncontainable
descend, with wounded hands, to Paris city.

>>>

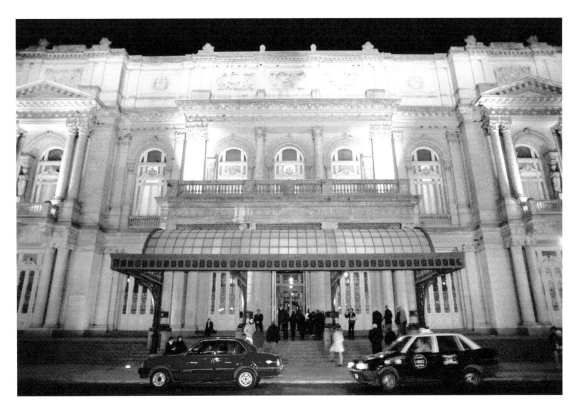

19. "Teatro Colón" /
"Teatro Colón."

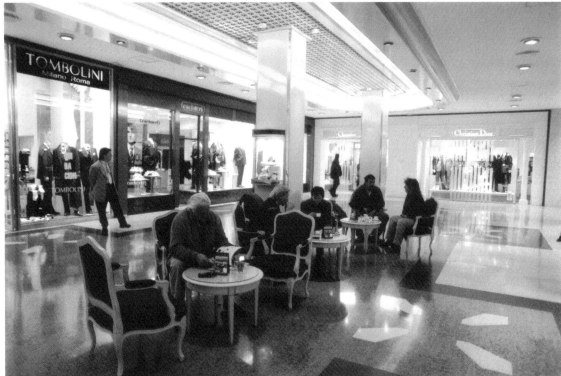

20. "Galerías Pacífico" /
"Galerías Pacífico."

Buenos Aires, imperturbable en sus fotografías
blanco y negro de principios de siglo, parece
no darse cuenta, amarrada al glorioso pasado
a los buques viajeros, a la loza grabada
a los anteojos de oro como insectos doblados
al borde de una página.

Pero aquí la vida es áspera y los dedos se cortan
con los bordes de latas, con papeles que chillan
como gatos furiosos, como un sol invertido la
boca come garras, y el sonido del viento mueve
el abecedario del hambre de la ira.

Todo lo que puedas decir del esplendor,
se muere, en esta noche, como un objeto roto.

Gladys Ilarregui

Buenos Aires, impassive in her black and white
turn-of-the-century photographs, seems not to
realize, moored to the glorious past
to large passenger ships, to engraved porcelain
to golden eye-glasses, like insects bent over
the edge of a page.

But life here is rough and fingers get cut
on the edges of cans, on papers that screech
like furious cats, like an inverted sun the
mouth eats claws, and the sound of the wind moves
the ABCs of the hunger of rage.

Everything you can say about the splendor,
is dying, tonight, like a broken object.

Translated by Sergio Waisman

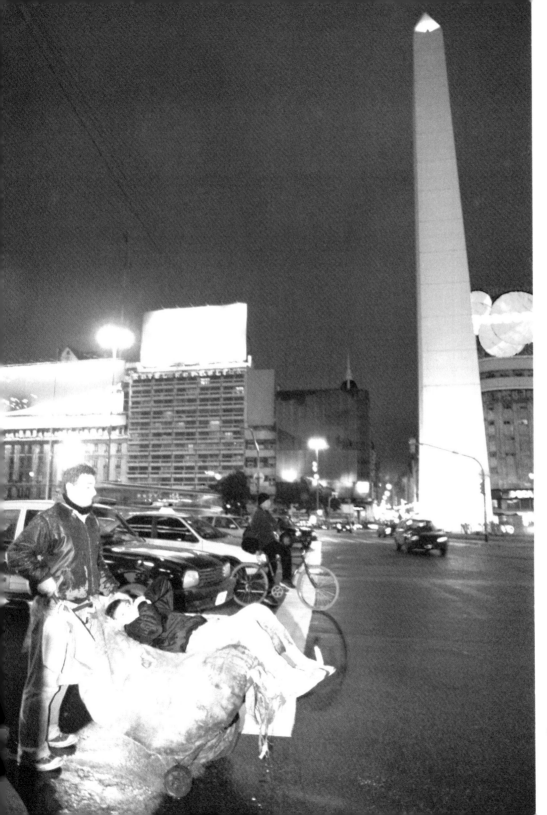

21. "Recorriendo la 9 de Julio" /
"Wandering about the
Avenida 9 de Julio."

Crisis in Buenos Aires:

Los colectores

La cosecha de la ciudad nunca ha sido
tan difícil de estimar si día a día
rebuscan en las bolsas de basura en la vereda,
aún bajo la ardiente ráfaga del sol de enero.

>>>

The Collectors

The city's yield has never been
more difficult to gauge as every day
they squeeze bin bags on pavements,
even in the hot blast of the January sun.

>>>

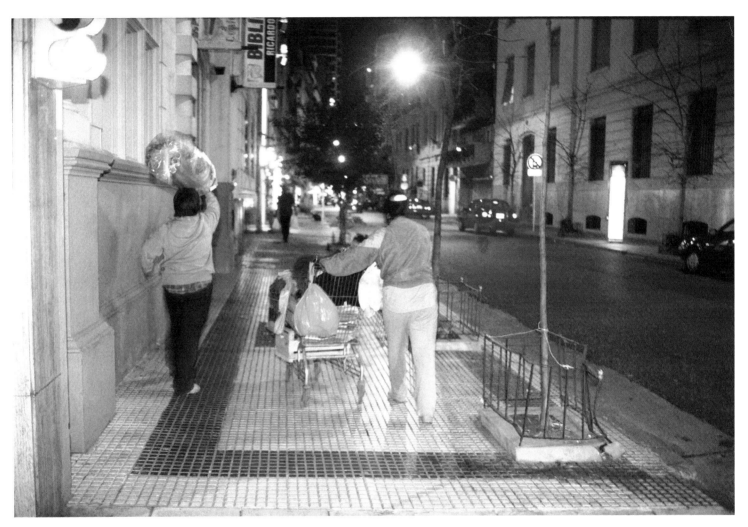

22. "En familia" / "With the Family."
 Wandering about the streets of the upper class neighborhood of Recoleta.

Tenemos en cambio una idea aproximada,
de a cuánto están el cartón, papel, vidrio
según el peso, pago en efectivo.
Pero nadie sabe aún el costo

por hectárea de ciudad, centímetro cúbico de basura,
de este prolijo reparto de calles
para una nueva raza de agricultores,
familias enteras en tren desde las villas.

>>>

We do have a rough estimate
of how much cardboard, paper, glass
goes for, as weighed, cash paid.
But no one yet knows the cost

per acre of city, bushel of rubbish,
of this neat allotment of streets
among a new breed of farmers,
whole families on trains from the slums.

>>>

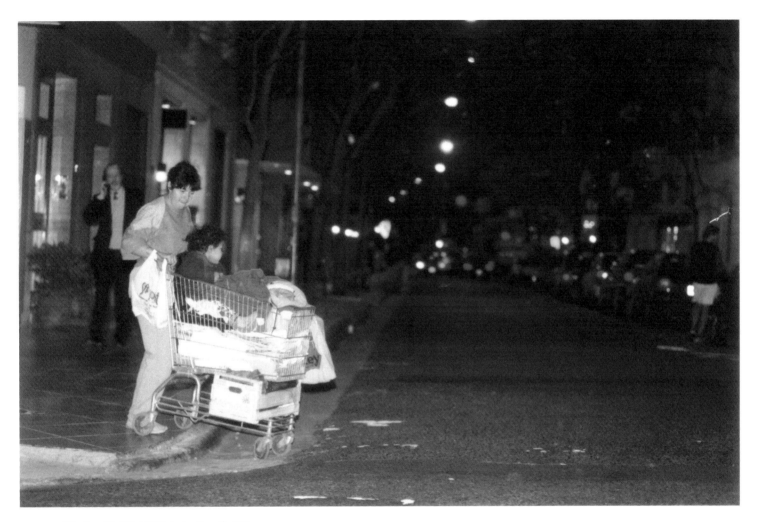

23. "En familia II" / "With the Family II."
 Wandering about the streets of the upper class neighborhood of Recoleta.

Crisis in Buenos Aires:

Pongámoslo de este modo:
si un niño es un brote,
llegados la primavera, el sol, la lluvia,
¿Se volverá un árbol?

Traducción al español: Delfina Muschietti y Cecilia Rossi

Let's put it this way:
If the children are saplings,
come spring, sun, rain,
will they turn trees?

Cecilia Rossi

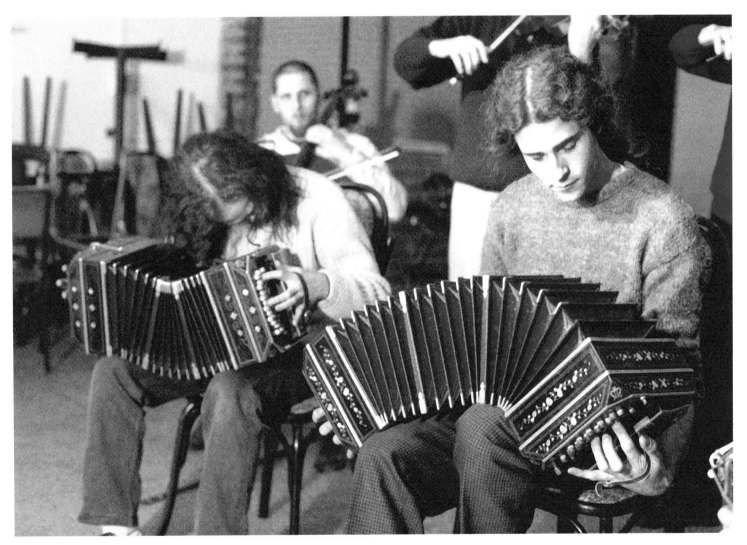

24. "Tangomanía" / "Tangomania."

Ciudad de oro

Es verano, hacia el fin de la tarde.
El sol baja bañando la calle estrecha;
siluetas negras se inclinan sobre bolsas de basura.

Si esto no fuera lo que es—
el diario revolver entre los desperdicios
en la costura abierta de las calles—

sería brillante luz de oro
y devotos peregrinos con ofrendas
bajo la amplia bóveda azul del cielo,

hasta la brisa podría silenciar
los tambores frenéticos de la protesta
calle abajo. Y yo podría

reclamar mi procedencia, jurar amor a
mi ciudad, una vez más apropiarme
de la letra del tango en la nostalgia del exilio.

Traducción al español: Delfina Muschietti y Cecilia Rossi

City of Gold

The time is summer, late afternoon.
The sun streams down the narrow street;
dark figures stoop by the bin bags.

If this were not what it is —
the daily rummaging through rubbish
in the open seams of the city's streets—

It'd be bright light, of gold
devout pilgrims come to offer votive
under the wide blue vault of the sky,

even the breeze would succeed in
silencing the frantic drums of the sit-in
on the road below. And I could

claim ownership, vow love
to my city, once again pre-empt
the tango lyric in the nostalgia of exile.

Cecilia Rossi

25. "Las Madres de la Plaza" / "The Mothers of the Plaza." Plaza de Mayo.

Crisis in Buenos Aires:

Buenos Aires, 2002

En mi memoria, la ciudad
no está hecha de fachadas
o maquillada de tristezas,
su máscara oscureciendo
balcones, ventanas –
escenarios de cartón
en que ensayás
una y otra vez
esta salida al encuentro
vestida de naranja
el último color
de otro adiós.

Vení que en mi ciudad
el horror de hoy no existe
y el atlético* es un club
y el garaje un estacionamiento
y la escuelita un lugar para aprender
historia
y el futuro un abanico abierto
de sendas y brisas
desembocando al mar.

(fragmento)

El atlético, el garaje, y la escuelita fueron centros de tortura durante la dictadura militar argentina.

Silvia Tandeciarz

Buenos Aires, 2002

In my memory, the city
is not made of façades
or done up with sadness,
its mask darkening
balconies, windows—
cardboard stages
where you practice
time and again
dressed in orange
this exit to meet
the last color
of another goodbye.

Come here, for in my city
today's horror does not exist
and the Athletic is a gym
and the Garage is a parking lot
and the Little School is a place to learn
history
and the future is an open fan
of paths and breezes
flowing into the sea.

(fragment)

The Athletic, the Garage, and the Little School were clandestine detention centers of torture during the military dictatorship in Argentina. (Poet's Note)

Translated by Sergio Waisman

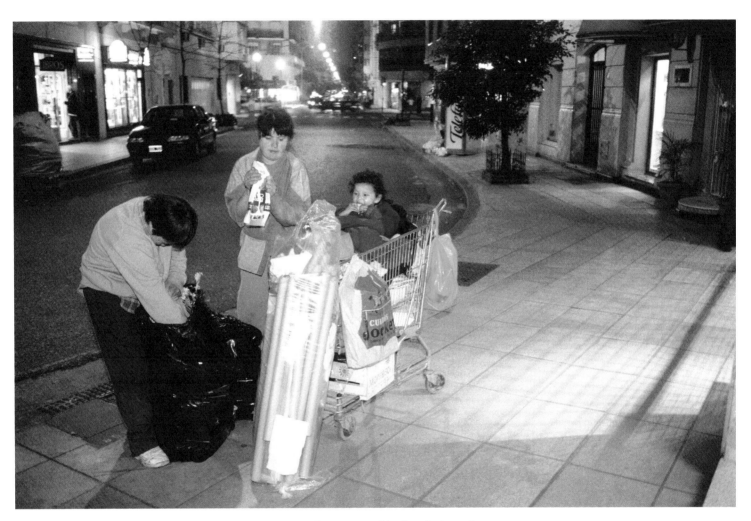

26. "Profesión: cartoneros" / "Profession: Cardboard Gatherers." Neighborhood of Recoleta.

me despierto en la noche
recién dormida
son las 12
ruidos de bolsas de plástico papeles
cartones cáscaras (siempre Pasolini!!)
un frus frus que ronronea
en la puerta de casa
casi pegado a mi ventana
casi
adentro donde dormimos cada uno
en su cama
después de cenar
después de cerrar la bolsa con los
desperdicios restos *trash* sacarla
a la puerta como todas las noches
dentro de los dispositivos adecuados
garbage dicen en inglés
en la vereda afuera

>>>

I wake up in the night
not long asleep
12 am
a rustle of plastic bags papers
cardboard, eggshells (again Pasolini!)
a russ-russ that purrs
at the front door
almost beside my window
almost
inside where we all sleep each one
in their own bed
after dinner
after closing the bin bag full of
rubbish leftovers trash taking it out
placing it by the door like every other night
inside the proper receptacle
garbage they say in English
in the street outside

>>>

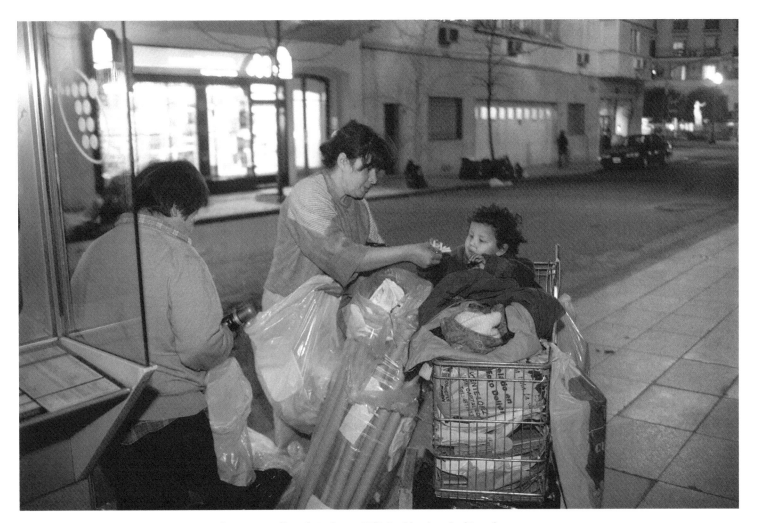

27. "Profesión: cartoneros II" / "Profession: Cardboard Gatherers II." Neighborhood of Recoleta.

la familia busca y rebusca
en eso que llamamos cotidianamente
La Basura
van con un carrito y acoplan nada
sobre nada
-no estábamos acostumbrados
es un ruido nuevo sorpresivo
pero vuelve ahora cada noche

>>>

the family searches and rummages
about in what we always call
La Basura
they push a small cart and pile nothing
upon nothing
-we weren't used to it-
it is a new sound, surprising
but now it returns every night

>>>

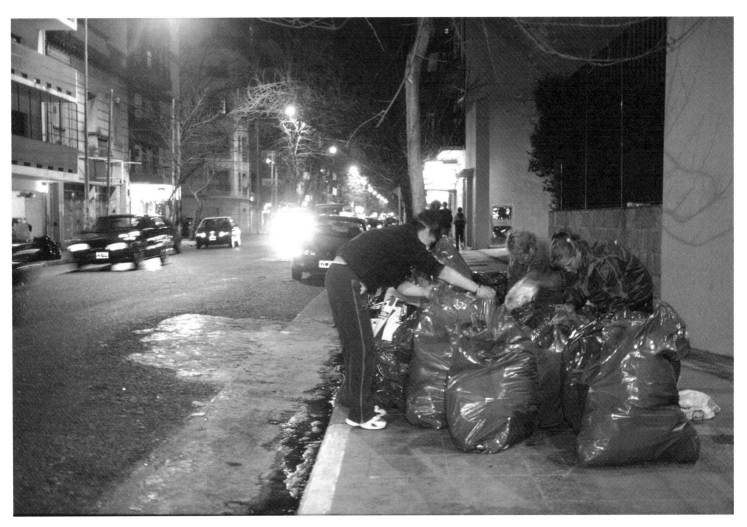

28. "Profesión: cartoneros III" / "Profession: Cardboard Gatherers III."
 Neighborhood of Palermo, intersection of Calles Salguero and Juncal.

es un desgarro
imaginarlos ahí afuera
frus frus
dale que te dale sin descanso
afantasmada la carne
adelgazada la vida
nada sobre nada
de los cuerpos
en el aire inmóvil
de la noche de Olivos
nada
sobras
nada

Delfina Muschietti

shocking
to think them out there
russ-russ
without rest over and over
their ghost-like flesh
life thinning
nothing upon nothing
in the still air
of the night in Olivos
nothing
left
over
nothing

Translated by Delfina Muschietti and Cecilia Rossi

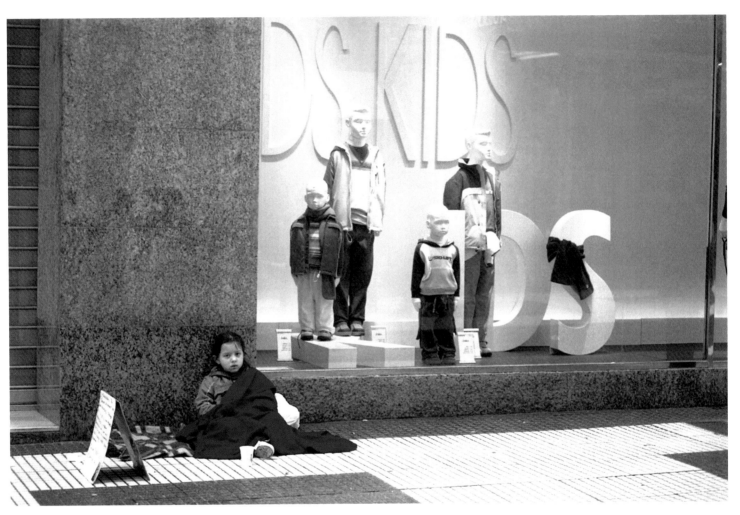

29. "Los hombres del mañana" / "Tomorrow's Men." Calle Florida.

pasea su futura amnesia
infantil
y su shock anestesiado
desvaído
por los trenes de Retiro
por el subte cavernoso
que la abriga de ese frío
mi hija ¿y si fuera?
ojos brillantes piel bruna
4 o 5 años esbeltos
con su estampita roñosa entre
los dedos
mi hija, ¿y si fuera mi hija?
qué vértigo sube cuando
se piensa
cuatro años expuestos
a cualquier mano de hombre
o muchacho
sin doblez de sábana
sin leche

she walks her future infantile
amnesia
and her anaesthetized shock
blurred
on the trains of Retiro
on the cavernous subway
that shelters her from the cold
my daughter, what if she were?
shiny eyes brown skin
4 or 5 slender years
with her grimy holy print
between her fingers
my daughter, what if she were my daughter?
a vertigo rises when
one thinks
four years exposed
to the hand of any man
or boy
no folded back sheets
no milk

>>> >>>

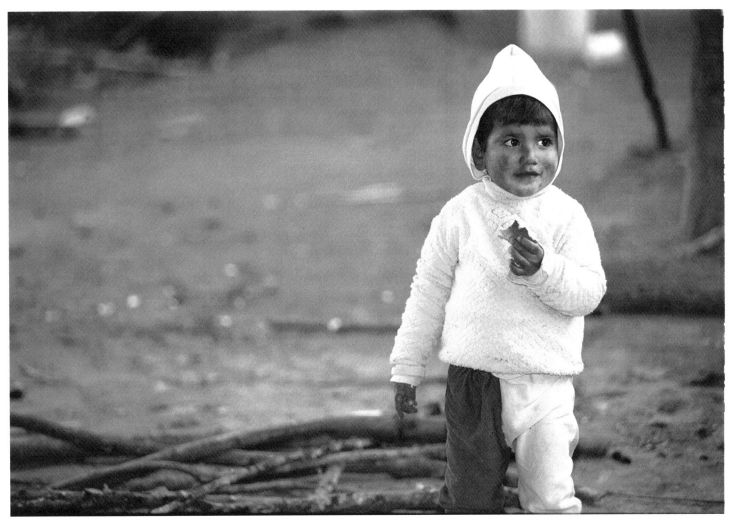

30. "Pan" / "Bread."
 A malnourished child in the province of Tucumán, in 2002.

la boca abierta para recibir
el golpe
desnudo y la sangre llena
que desborda el labio
el sexo aún no nacido
¿y si fuera Eugenia
alguna otra vez en otra vida
perdida de familia
sola
sin genealogía
de abuelas tías primas
yirando por la calle
a los cuatro años
desvalidos
y yo aquí inmóvil
sin poder nada?

Delfina Muschietti

her mouth open just to receive
the blow
naked and thick blood
that bursts her lips
her sex not yet born
what if she were Eugenia
another time in another life
lost from family
alone
without the genealogy
of grandmothers aunts cousins
walking the streets
at four
helpless
and I here unmoving
with power
to do nothing?

Translated by Delfina Muschietti and Cecilia Rossi

Appendix

Using *Crisis in Buenos Aires: Women Bearing Witness* in the Classroom: Sample Lessons and Themes

Stacey Hendrix

THE POSSIBILITIES FOR INSTRUCTIONAL use of *Crisis in Buenos Aires: Women Bearing Witness* are many. Because it includes bilingual poetry and photographs complemented by testimonies, explanations of the socio-historical context, and analysis of the poetry and photography, it can be used in classes taught in Spanish or English and in a variety of disciplines such as Spanish language, literature, Latin American civilization and history, and Women's Studies and journalism. It would be ideal for a literature or culture course taught in a study abroad program in Argentina. The lessons and activities included here are adaptable across disciplines and levels, and teachers in many fields will be able to make use of the wealth of realia, interpretation, literature, and art included in this book. This material, which presents the Argentine crisis of 2001 through images, poetry, and testimony, allows students to experience the human dimensions of the crisis. Readers and viewers are drawn into the personal struggles of ordinary people and examine them as compassionate global citizens as opposed to detached voyeurs. This unique collection creatively exposes students and educators to the Argentine crisis from diverse perspectives; it offers comprehensive yet manageable resources that can readily be adapted to classroom use.

The following classroom applications of *Crisis in Buenos Aires* are divided into four sections: Openers and Introductory Activities, Sample Lesson Plans for an Intermediate Spanish Course, Themes for Discussion or Composition, and Topics for Further Research.

This first lesson plan is adapted from one that was successfully piloted by the Spanish 107 (intermediate Spanish) instructors at the University of Delaware in October 2003. I served as course coordinator and taught three of its twenty sections. Upwards of 400 students throughout the day were asked to report, for the entire fifty minutes of their regularly scheduled class, to the traveling exhibit of photography and poetry entitled "Buenos Aires: A Tale of Two Cities. Mapping the New Reality through Poetry and Photography" organized by Cynthia Schmidt-Cruz, associate professor of Spanish and director of the Latin American Studies Program, and Gladys Ilarregui, assistant professor of Spanish. The exhibition was complemented by numerous events related to crisis and change in Latin America, and featured visits from Argentine specialists whose work is included in this book: journalist Santiago O'Donnell, photojournalist Silvina Frydlewsky, and poet and translator Delfina Muschietti.

At the time of the exhibit, our students were studying the history and culture of Argentina as well as vocabulary related to art. The activity was designed to be engaging, student-friendly, and something that they could complete independently with minimal assistance from the instructor. Our students and instructors did not have the benefit of the essays provided in this book to help prepare us to discuss the events surrounding the crisis. Nevertheless, an article announcing the event in the University of Delaware's online news resource "UDaily" provided some basic background information that students were required to read as part of the lesson plan. Students reacted favorably to the assignment, and instructors provided positive feedback. The lesson found in Section II below is an adaptation of the original one that was designed for the gallery visit, and the activities found in the other three sections have been specially designed to accompany the material in this book.

I. Openers and Introductory Activities

Free Association/Writing: Ask students to jot down the first thought(s) that come to their minds when you say "*dinner,*" "*trash,*" "*pots and pans,*" "*Argentina,*" "*Buenos Aires,*" and/or "*dinner in Buenos Aires.*" Then read an excerpt from one of the essays or one of the poems and/or show photos.

Free Association/Drawing: Have students draw what they envision when they hear the word "*home.*" Then show them the photo entitled "Mi casa" / "My house" (photo 13). Variation: Read one of the poems rich in concrete images such as "Salmo por la ciudad de Buenos Aires" / "Psalm for the City of Buenos Aires" by Ivonne Bordelois aloud twice, first at a normal pace, and the second time much more slowly. Ask students to sketch (or visualize) the images they hear.

Interpretation of a Photo: Prior to presenting background information on the crisis, show students one or more photographs that depict protestors or other people affected by it such as "Cacerolazo popular" / "Popular *Cacerolazo*" (photo 7). Ask students to describe what is going on in the photograph, and give their reactions and interpretations. Possible questions are: Who/what is in the photo? What emotions are conveyed and how? Where do you think the photograph was taken? When? By whom?

Have students continue to focus on the photo as you read them excerpts from one or more of the essays, and ask: How did your initial perception of this photo change after hearing the reading? Revisit previous questions and use them to initiate a discussion: Who/what is in the photo? What emotions are conveyed and how? Where do you think the photograph was taken? When? By whom?

Variation: Explore contrasts by using a single photograph depicting contrasting images such as "Los hombres

del mañana" / "Tomorrow's Men" (photo 29), "Ciudad imponente e impotente" / "Imposing, Impotent City" (photo 9) or "Contrastes en el Teatro Colón" / "Contrasts at the Teatro Colón" (photo 12). Ask students to identify and interpret the contrasting aspects of these images.

Variation: Have students compare and contrast two separate photos depicting the same place at different moments such as "Ciudad imponente e impotente" / "Imposing, Impotent City" (photo 9) and "Recorriendo la 9 de Julio" / "Wandering about the Avenida 9 de Julio" (photo 21). Both offer views of the obelisk, one a daytime view with a solitary, desperate man and the other a dark nighttime view curtained by images of the "colectores." Other contrasting images include "Teatro Colón" / "Teatro Colón" (photo 19) and "Contrastes en el Teatro Colón" / "Contrasts at the Teatro Colón" (photo 12).

Follow up/Debriefing: Have students revisit/discuss any of the above activities after reading the essay by Anthony Faiola and/or the essay by Santiago O'Donnell.

Reflection: Reflect on a recent crisis in the United States. How might a foreigner with no previous knowledge of Hurricane Katrina react to a photograph of Katrina victims stranded in their homes or on flooded roadways?

Writing Exercise: Have students write their own poem, using the style of one of the poems in this book, in which they express their emotions about or their reaction to a recent domestic or international crisis.

II. Sample Lesson Plans for an Intermediate Spanish Course

While these plans are designed to be used in a four day sequence, any of them can be used in isolation after the students have been provided with background material about the crisis.

Day one: Choose one of the opener activities from Section I and then share the essay by Anthony Faiola and/or the essay by Santiago O'Donnell or excerpts from them.

Day two: Show students two (or two groups) of Frydlewsky's photographs: one "dark" or "nighttime" photo such as "Desolación" / "Desolation" (photo 10), "Madre del dolor" / "Mother of Sorrow" (photo 15), or "El oro de los pobres II" / "Poor-Person's Gold II" (photo 18) and one "lighter" or "daytime" photo such as "Ciudad imponente e impotente" / "Imposing, Impotent City" (photo 9), "Café Tortoni, tarde de domingo" / "Café Tortoni, Sunday Afternoon" (photo 5), or "Café Tortoni, tarde de nostalgia" / "Café Tortoni, Nostalgic Afternoon" (photo 6). Ask them to complete the following exercise:

Loosely sketch two of the photos (one "dark" and one "lighter") and invent your own titles for them in Spanish. Then describe the photos and the emotions you feel while looking at them.

Photo 1.) Título: _____

	descripción: _____

Photo 2.) Título: _____

	descripción: _____

Of the photos you have seen, choose one that, in your opinion, is the most moving and explain the overall feeling produced by its composition.

La foto que me afecta más es la que ...porque...

Day Three: Have students complete the following:

Many of the poems evoke images, memories, or symbols of a brighter past in Buenos Aires and contrast them with current street images of political protest and economic crisis. Read the following excerpt, and use it as inspiration to write your own poem (in Spanish) about a place or situation with which you are familiar and that has changed.

Cuando era niña	When I was a girl	Cuando era niño/a…
Argentina fue el General San Martín jinete en unicornio blanco galopando heroico por las páginas de *Billiken*. Después Argentina me supo al vino triste y la palabra sabia de amigos nuevos que burlaron la guerra sucia y nos trajeron un mar de ausentes reventando en las pupilas. *Marjorie Ross*	Argentina was General San Martín galloping heroically through the pages of *Billiken* on a white unicorn. Then Argentina became sad wine and the wise word of new friends mocking the Dirty War bringing us a sea of absent people bursting in their pupils. *Translated by Sergio Waisman*	_____ _____ _____ _____ _____ _____ _____ _____ _____ _____ _____ _____

Day Four: Have students complete the following:

Choose a poem and a photograph that you feel "work together." In Spanish, explain why the two go well together.

Poema (first line of the poem you chose):

Foto (roughly sketch the photo here):	**¿Qué tienen en común?**

III. Themes for Discussion or Composition

The following themes can be adapted for use in a wide variety of disciplines (such as Spanish language, Hispanic literature, Latin American Studies, multicultural education, political science, Women's Studies, English composition, and economics):

1. Use the preface and the essays in this book to find and identify the significance of the following terms: *cacerolazo, cartoneros,* The Argentine crisis of 2001, *corralito,* "The Dirty War."

2. After reading Anthony Faiola's essay, which individual's story of struggle did you find the most remarkable and why? Find a photograph (and/or poem) that illustrates or complements this story and explain why you chose it.

3. Explore the effects of economic crisis on children and the theme of global responsibility through photos and poems depicting children. Suggested photos are "Madre del dolor" / "Mother of Sorrow" (photo 15), "La desnutrición: la madre de la desesperanza" / "Malnutrition: The Mother of Despair" (photo 16), "En familia II" / "With the Family II" (photo 23), "Profesión: cartoneros II" / "Profession: Cardboard Gatherers II" (photo 27), "Los hombres del mañana" / "Tomorrow's Men" (photo 29), and "Pan" / "Bread" (photo 30). Suggested poems are "Muerte por hambre" / "Death by Hunger" by Diana Bellessi and "pasea su futura amnesia" / "she walks her future infantile" by Delfina Muschietti.

4. In her essay, Delfina Muschietti speaks of the "border" or "divide" between the "haves" and the "have-nots," between the discarder and the collector of the discards, between those inside their homes in their beds and those outside picking through their trash. Analyze poetic images that describe these two sectors and how those who still have a home and food (or those who are relatively secure) react to this new reality of poverty. Suggested poems are "Buenos Aires: historia del anochecer" / "Buenos Aires: Story of Nightfall" by Gladys Ilarregui and "me despierto en la noche" / "I wake up at night" by Delfina Muschietti. Also see Santiago O'Donnell's essay.

5. Several poems depict the change in Buenos Aires. Read Gladys Illarregui's article and the poems "Buenos Aires: historia del anochecer" / "Buenos Aires: Story of Nightfall" by Gladys Ilarregui and "me despierto en la noche" / "I wake up at night" by Delfina Muschietti. Explore this concept of change and how they express the transformation and the new reality of the city.

6. Discuss the theme of nostalgia or mental escape for survival. Suggested photos are "Café

Tortoni, tarde de domingo" / "Café Tortoni, Sunday Afternoon" (photo 5) and "Café Tortoni, tarde de nostalgia" / "Café Tortoni, Nostalgic Afternoon" (photo 6). Suggested poems are "Ciudad de oro" / "City of Gold" by Cecilia Rossi, "Buenos Aires, 2002" / "Buenos Aires, 2002" by Silvia Tandeciarz and "Cuando era niña" / "When I Was a Girl" by Majorie Ross.

7. Trace the journey of a cardboard box, including its origin, destination, collection and sale (by a *cartonero*) using David William Foster's essay and the following photographs: "En familia" / "With the Family" (photo 22), "En familia II" / "With the Family II" (photo 23), "Profesión: cartoneros" / "Profession: Cardboard Gatherers" (photo 26), "Profesión: cartoneros II" / "Profession: Cardboard Gatherers II" (photo 27) and "Profesión: cartoneros III" / "Profession: Cardboard Gatherers III" (photo 28).

8. Discuss the use of sound in "me despierto en la noche" / "I wake up at night" by Delfina Muschietti. Variation: What is lost or altered in translation? Is anything gained? Consult Delfina Muschietti's essay.

9. Explore the theme of gender and power by comparing photographs such as "Tolerancia cero" / "Zero Tolerance" (photo 4), "Cacerolazo popular" / "Popular *Cacerolazo*" (photo 7), "Indignación, impotencia..." / "Indignation, Impotence..." (photo 8), and "Ciudad imponente e impotente" / "Imposing, Impotent City" (photo 9). For a perspective on the gender context, see the essay by David William Foster.

10. Explore the use of descriptions that appeal to the senses in "Regina/Reina" / "Regina/ Queen" by Gladys Ilarregui. Study the use of alliteration (the repetition of consonant sounds) in "X" by Zulema Moret.

11. Explore the theme of trash as treasure (or "glorified garbage") in "Regina/Reina" / "Regina/Queen" and "Buenos Aires: historia del anochecer / Buenos Aires: Story of Nightfall" by Gladys Ilarregui and "Ciudad de oro" / "City of Gold" by Cecilia Rossi. See the essays by Gladys Ilarregui and David William Foster.

IV. Topics for Further Research

1. Research and compare the symbolic demonstrations of the "Madres de la Plaza de Mayo" and the *cacerolazos* of 2001-2002.

2. Compare the causes and effects of the Great Depression and the Argentine crisis of 2001.

3. From an economic perspective, explore the likelihood of and circumstances necessary to create a similar crisis in the United States.

4. The last line of "Ciudad de oro / City of Gold" by Cecilia Rossi is "the tango lyric in the nostalgia of exile." Search for tango lyrics that express nostalgia or loss and share them with the class, explaining the situation that they portray.

5. Several essays, poems (such as "Buenos Aires: historia del anochecer / Buenos Aires: Story of Nightfall" by Gladys Ilarregui), and photographs (such as those depicting the beautiful "Teatro Colón") allude to Argentina's "Belle Époque"—the end of the nineteenth century when its economy boomed and Buenos Aires was transformed into one of the world's most sophisticated metropolises with grand boulevards and plazas, lavish mansions and public buildings, and extensive parks. Research this period in the history of Buenos Aires and explain why it has been called the Paris of South America. Is this label still apt? Why or why not?

About the Contributors

Diana Bellessi, one of the leading contemporary Argentine poets, lives in Buenos Aires. She studied philosophy at the Universidad National del Litoral, and in the early 1970s traveled the Americas on foot. To date Bellessi has published nineteen books; among her most recent are *Lo propio y lo ajeno* (ensayo, 1996 y 2006); *Antología poética* (2002); *Mate Cocido* (2002); *La edad dorada* (2003); and *La rebelión del instante* (2005). Additionally she has published collections of contemporary North American women poets in translation including *The Twins, The Dream* (Arte Público, 1996). She has received Guggenheim and the Fundación Antorchas fellowships.

Analía Bernardo is a journalist, teacher, and writer in Buenos Aires. She investigates sacred feminine anthropological traditions, and has published three digital books about feminine archetypes. Bernardo participates in the "Goddess" movement in Argentina, disseminating spiritual feminism, a topic about which she has given numerous workshops in the Hannah Arendt Institute.

Ivonne Bordelois is an essayist and poet. After graduating from the University of Buenos Aires she studied linguistics in France, Holland, and the U.S. where she earned a doctorate under the direction of Noam Chomsky. In 1994 she returned to Buenos Aires and resumed her literary activity. Among other distinctions she has received a Guggenheim Fellowship as well as awards for her books *Un triángulo crucial: Borges, Lugones y Güiraldes* (1999) and *El país que nos habla* (Sudamericana 2005). Other books include *Correspondencia Pizarnik* (Planeta 1998), *La palabra amenazada* (Libros del Zorzal 2003), and *Etimología de las Pasiones* (Libros del Zorzal 2006).

Marta Cwielong, a resident of Buenos Aires, has published three volumes of her poetry—*Razones de huir*, *De nadie*, and *Jadeo Animal*—as well as an anthology published in Valencia: *Morada*. She is the co-director of the publishing house Libros de Alejandría.

Olga Drennen is a teacher, poet, translator, essayist, and author of children's books. A resident of Buenos Aires, she has coordinated literary workshops for children and adults, and has served on juries for prizes in children's literature. Among her literary works, which have won various awards, are the children's books *Wunderding y otros escalofríos, Asesinatos en la escuela del perro,* and *Nadie lo puede negar;* and poetry books *Transparencias* and *Fiesta Brava.*

Anthony Faiola is the New York Bureau Chief for *The Washington Post*. From 1996 to 2003 he was the *Post's* Buenos Aires bureau chief, covering news across South America including the Argentine financial crisis and the fall of Alberto Fujimori in Peru. Subsequently, from 2003 until February 2007, he served as Northeast Asia bureau chief for the *Post*, covering Japan and the two Koreas.

Valería Flores is a teacher, poet, and feminist activist. Her recent book, *Notas lesbianas, reflexiones sobre la desidencia sexual* (Hipólita 2007), collects her latest essays. Flores lives in Neuquen, Argentina, where she conducts workshops and seminars dedicated to lesbian issues.

David William Foster, Regents' Professor of Spanish, Humanities, and Women's Studies at Arizona State University, has authored nearly fifty and edited over thirty books on Latin American literature and culture. His research interests focus on urban culture in Latin America, with emphasis on issues of gender construction and sexual identity, as well as Jewish culture. Some of his recent publications about Argentina include *Buenos Aires: Perspectives on the City and Cultural Production* (University of Florida Press, 1998), *Violence in Argentine Literature; Cultural Responses to Tyranny* (University of Missouri Press, 1995), and *Contemporary Argentine Cinema* (University of Missouri Press, 1992).

Silvina Frydlewsky, a native of Buenos Aires, studied Communication at the University of Buenos Aires and has worked as a photojournalist since 1989. From 1990 to 2000 she lived in Spain where she worked for Spanish and international publications including *El País, EL Mundo, La Vanguardia, ABC, The New York Times, Time Magazine, Associated Press,* and *Financial Times.* Currently she lives in Argentina, collaborating with reporters for *The Washington Post* and other publications.

Barbara Gill is a journalist and poet who lives in Boulogne, Argentina.

Stacey Hendrix, Spanish instructor at the University of Delaware, received her M.A. in Spanish from Colorado State University. She teaches grammar and composition courses, and has served as coordinator of first year language courses. Her interests include developing instructional materials and curricula for specific purposes and facilitating language and multicultural awareness workshops for educators.

Gladys Ilarregui, a native of Argentina, is an assistant professor at the University of Delaware. She has published six books of poetry, which have won prizes in Mexico, Argentina, and the U.S., including the Arthur P. Whitaker prize from the Middle Atlantic Council of Latin American Studies for her collection *Poemas a Medianoche* (Tierra Firme 2003). Ilarregui's poetry is part of the oral record of Latin American Literature in the Library of Congress, and her work was presented at the University of Salamanca in 2006.

Her book about sixteenth-century colonial women will be published by the Benemérita Universidad Autónoma of Puebla, Mexico.

Zulema Moret is a native of Buenos Aires. As director of a writing school in Barcelona, she published over 15 volumes of creative works. She has published five books of her poetic works as well as the prize-winning *Artistas de lo que queda: las escrituras de Escombros* (Madrid: Tramas), which deals with Argentine art and social movements. She is currently an assistant professor of Spanish at Grand Valley State University.

Delfina Muschietti is a poet, critic, translator, and professor at the University of Buenos Aires where she directs the Poetry and Translation Project. Muschietti curated the complete works of Alfonsina Storni and has authored many articles of literary criticism about Argentine poetry and translation theory. Her published collections of poetry include *Los pasos de Zoe* (1993), *El rojo Uccello* (1996), *Enero* (1999), *Olivos* (2002). She has translated and compiled the poetry of Pier Paolo Pasolini, Atilio Bertolucci, and Amelia Rosselli. Her forthcoming book of essays, *Más de una lengua: poesía, subjetividad y género*, will be published by Biblos.

Santiago O´Donnell is the foreign editor and columnist at *Página 12* and edits *Surcos en América Latina*. A native of Buenos Aires, he earned a Master's Degree in International Journalism from the University of Southern California, and subsequently worked for the *Los Angeles Times* and *The Washington Post*. In 1994 he returned to Buenos Aires, where he has written and reported for major publications including *Newsweek*, NPR, *Clarín, La Nación,* and *International Justice Tribune*. He created and directed *Citizen Power* magazine and was managing editor at *TXT* magazine.

Majorie Ross is a poet who lives in Buenos Aires.

Cecilia Rossi is a writer and translator. A native of Buenos Aires, she now lives in Norwich, England where she recently completed her Ph.D. in Literary Translation at the University of East Anglia. The topic of her dissertation was the English translation of Alejandra Pizarnik's poetry. Rossi's poetry, short stories, and translations have been published in various journals, as well as anthologized in *The Pterodactyl's Wing* (Parthian Books, 2003).

Cynthia Schmidt-Cruz is an associate professor of Spanish at the University of Delaware where she served as director of the Latin American Studies Program from 2003-2006. She has published numerous studies about contemporary Latin American literature, including the book, *Mothers, Lovers, and Others: The Short Stories of Julio Cortázar* (State University of New York Press, 2004). Her current project deals

with the Argentine *novela negra*, or crime novel.

Katherine Silver works as an editor and consultant for a wide range of academic and trade publishing houses. Her most recent translations include the works of Antonio Skármeta, Pedro Lemebel, and Jorge Franco. Her collection of Chilean fiction, *Chile, A Traveler's Literary Companion*, was published by Whereabouts Press.

Silvia Tandeciarz is an associate professor at the College of William and Mary. Her current research focuses on cultural initiatives in Argentina that serve to process and transmit traumatic memories of the last dictatorship. She is also a translator and a poet. Her poetry won the Clarence Urmy Prize from Stanford University and the Voces Selectas of Luz Bilingual Publishing. In 2000 she published her first collection of poetry, *Exorcismos* (Betania).

Betty Tosso is a poet who lives in Buenos Aires.

Sergio Waisman, Associate Professor of Spanish at The George Washington University, was born in the U.S. to Argentine parents. He has translated five books of Latin American literature, including *The Absent City* by Ricardo Piglia (Duke University Press), for which he received a National Endowment for the Arts Translation Fellowship Award. He recently published *Borges and Translation: The Irreverence of the Periphery* (Bucknell University Press, 2005), as well as his first novel, *Leaving* (InteliBooks 2004).